Isabel Kuhl

Andy Warhol

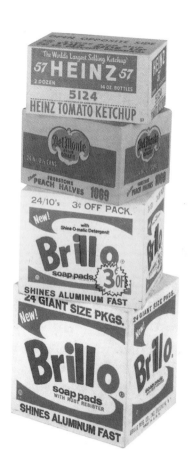

Prestel
Munich · Berlin · London · New York

Context

"New York is like
no other city.
It is an ugly city,
and it is dirty.
The climate is awful.
But for anyone
who has lived here,
no other place is
good enough."

Henry James

The Big Apple ...

... became the world's arts, media, and financial capital during the 20th century. The City that Never Sleeps had something to offer everyone—above all Andy Warhol.

Art is Life

By the 1950s, Paris was no longer the world's art capital. Famous galleries and museums of international standing were forging ahead in New York, the city that from now on would set the price of art around the world. With the success of Abstract Expressionism, European dominance of the art world came to an end. "Art is life—life is art" was the motto of artists everywhere. Pop artists found their motifs among everyday objects; and at "happenings," art, music, and theater fused, often with provocative results.

Claes Oldenburg preferred recreating everyday objects (here a bathroom washstand), sometimes made on a monumental scale.

Television ...

-→ ... was just setting out to conquer America in the 1950s, and

-→ ... by the end of the decade 90% of American homes had a set.

6

Broadway at the Corner
of 54th Street

Studio 54 was *the* New York disco during the late 1970s
and early 1980s. Located on Broadway at the corner of
54th Street, it was the premier partying venue for celeb-
rities and groupies, the rich and beautiful—Diana Ross,
Andy Warhol, John Travolta, Liz Taylor, Truman Capote,
Mick and Bianca Jagger all shared the dance floor with
other party animals. Fancy dress spectaculars were the
order of the day, and the more outrageous your costume,
the greater your chance of being admitted to disco's inner
sanctuary. A former television studio, Studio 54 not only
defined the sound of the disco era, it showed the world
what partying and drug-fuelled excess were all about.

"I think a painting is more
like the real world if it's
made out of the real world."

Robert Rauschenberg

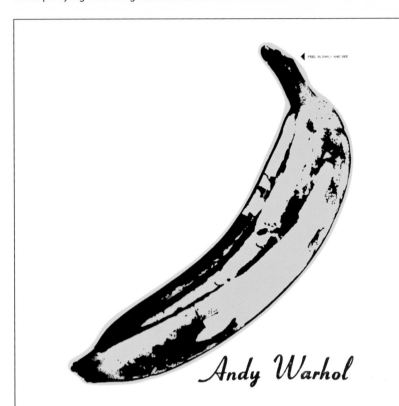

Andy Warhol

Rocking!

The meteoric rise of the group *The
Velvet Underground* started with Andy
Warhol. He discovered this wild bunch
of musicians in Greenwich Village.
Warhol hired the *Velvets* for his hap-
pening *Exploding Plastic Inevitable*.
With no rehearsal space because their
music was so loud, the band was able
to pump up the volume in Warhol's
studio, which was know as "the
Factory." The debut album of *The Velvet
Underground & Nico* came out in
1967, and Warhol himself designed its
artwork: a banana that could be
peeled off the cover (left).

7

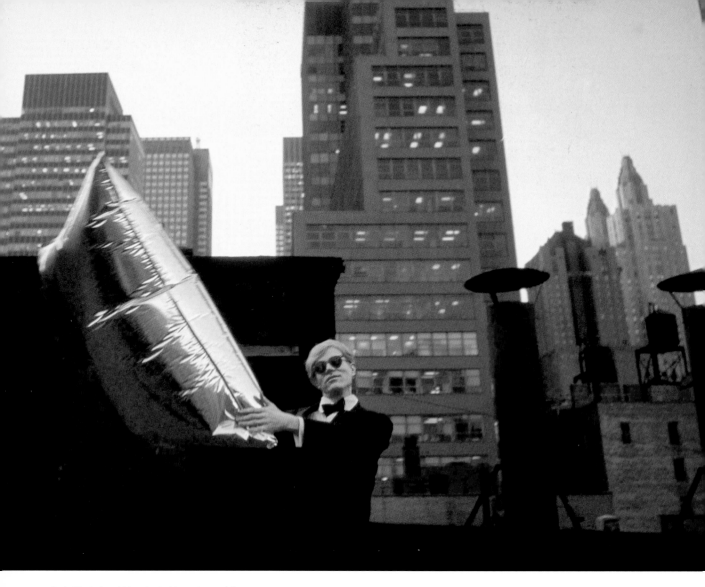

Andy Warhol and his adopted hometown of New York were on a steep upward curve in the 1960s. Here he's seen presenting his *Silver Clouds*, floating silver cushions.

Bohemia: Greenwich Village
in the 1950s.

The Big Apple Takes Over

After World War II, New York rapidly changed from America's industrial center to its undisputed cultural capital. Artists and writers in particular discovered the attractions of former factory buildings and warehouses in Manhattan.

Ferment in East Village

Andy Warhol's New York was in fact quite small, restricted mainly to the island of Manhattan—thirteen miles long and less than three miles wide—also simply called "the City" by the locals. When Warhol and his fellow student Philip Pearlstein moved from Pittsburgh to New York City, they first settled in the Lower East Side, a neighborhood seen as the center of alternative culture: hippies, lefties, and rock fans lived here side by side. Literary figures were also drawn to it because of its low rents and highly creative atmosphere. In the 1950s, writers Jack Kerouac, Allen Ginsberg, and Norman Mailer all lived there. By analogy with neighboring Greenwich Village, where Bob Dylan lived, the neighborhood was soon renamed East Village. In 1955, Norman Mailer and others began publication of the alternative weekly newspaper *The*

> "I am for an art that is political-erotical-mystical, that does something other than sit on its ass in a museum."
>
> **Claes Oldenburg**

9

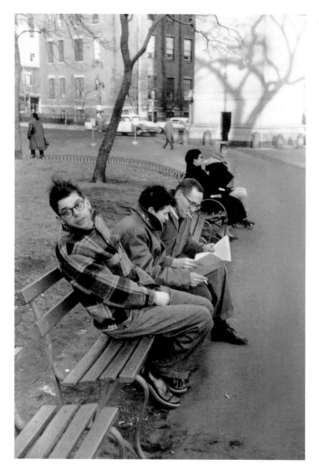

The Beat poets Allen Ginsberg (left) and Gregory Corso (middle), with publisher Barney Rosset, Washington Square, 1957.

Village Voice that went on to become the mouthpiece of New York's intellectuals.

On the Road with the Beats

Even before the hippies found each other, writers who became known as the "Beat Generation" were doing their own thing in New York's bohemian underground. With their unconventional and occasionally obscene works, the beats, or beatniks, upset conventional society. The word "beat" means tired, down and out, but also refers to rhythm in music: the beat of music and poetry. But it was less music and more drugs and alcohol that influenced Beat writers, among them Jack Kerouac, Allen Ginsberg, and William S. Burroughs. Kerouac's celebrated novel *On the Road* is an account of the drug-, jazz-, and sex-fuelled road trips made by him and his friends across the United States.

Media City

After World War II, it was not only alternative New York that grew and flourished. The biggest newspapers, major television stations, and the majority of American publishing houses all established themselves there. The country's economic upswing was associated with a flood

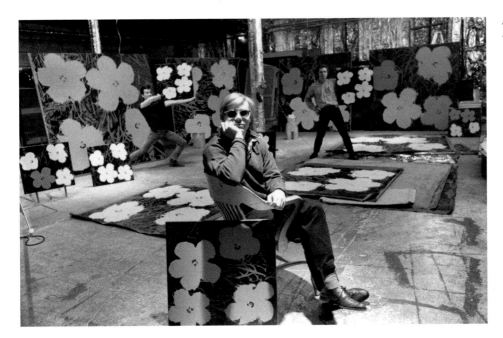

Andy Warhol in his studio in
a former hat factory in Manhattan.

of advertising—from New York. With the number of self-service stores increasing, lavish advertising was required for the products on sale in them—luckily for Andy Warhol, who in the 1950s sought work as a commercial artist.

The 1960s saw a building boom as foreign investors also discovered the Big Apple and built prestigious skyscrapers. The Verrazano-Narrows Bridge was opened in 1964 to connect Brooklyn and Staten Island. Also located to the east of Manhattan, the borough of Queens hosted the 1964/65 World's Fair at Flushing Meadows Park.

A Changing City

However, things soon went rapidly downhill for the city and its residents, especially in the 1970s. 600,000 jobs—three out of five—were axed. By 1975, New York was an economic wreck: it was unable to pay its debts, and only a loan from the federal government prevented it from going bankrupt. Whole neighborhoods deteriorated rapidly, and middle-class families moved out of the center into the suburbs. At least the empty factories in Manhattan offered artists whole open-plan floors that were perfect as living and working spaces. Rents even fell.

Warhol and his crew also moved into an empty factory building in Midtown, and he called his new studio "the Factory." SoHo and TriBeCa were parts of town that had seen industry move out over the course of the century. In 1949, there were still around one million factory workers—one-eighth of all residents—in New York City. Now it became an art center.

Merce Cunningham and a member
of his dance troupe performing
Rain Forest in 1968.

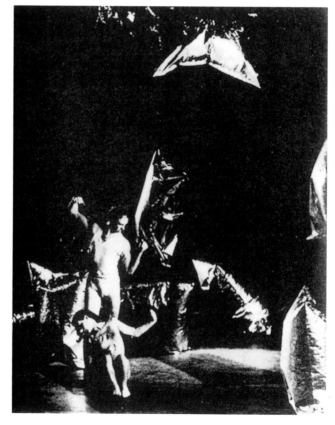

Old World—New World

World War II and the fierce condemnation of modern art
by the Nazis had led to a wave of European avant-garde
artists exiling themselves in the United States. Many of
them headed to New York: Max Ernst and Marcel
Duchamp, for instance, as well as Marc Chagall and
Yves Tanguy. They had a huge influence on contempor-
ary American art. By the same token, the importance of
American Abstract Expressionism for European artists
should not be underestimated. A whole string of young
artists—including Jackson Pollock, Willem de Kooning,
and Mark Rothko—had set out to discover new methods
and ideas in art.

Pop Up

1961 was an eventful year in New York. Jim Dine exhib-
ited his assemblages at the Martha Jackson Gallery.
Tom Wesselmann's *Great American Nudes* were shown
at the Tanager Gallery. Claes Oldenburg presented his
monumental replicas of everyday objects in his own studio.

Roy Lichtenstein exhibited his pictures inspired by
comic strips at the Leo Castelli gallery. Over the coming
years, Castelli's gallery would organize numerous exhibi-
tions of the work of young Pop artists, and help many of
them on the road to success.

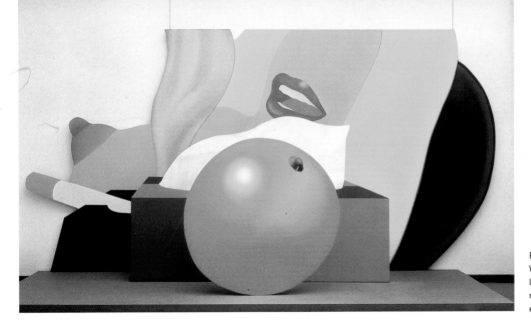

Pop artist Tom Wesselmann painted largescale female nudes set alongside everyday objects.

Sounds Different

New York was well to the fore not only in the visual arts. In new music, too, the city didn't need to be modest. Californian by birth, John Cage made a name for himself in New York both as a theoretician and organizer of "happenings." By inserting nails, bolts, and lengths of rubber into the strings of pianos, he produced completely new sounds. In marked contrast, his piece called *4'33"* makes no sound at all: its three movements are "composed" of just over four and a half minutes of silence. The piece was premiered in 1952. Cage was also interested in electronic music. He began to collaborate with the dancer and choreographer Merce Cunningham, who at the time still danced with the Martha Graham Dance Company. In his own choreography, chance was more important to Cunningham than structured plot— as it was for Cage in his compositions—thus allowing new forms to emerge. The results of their collaborative efforts were revolutionary, and completely changed the relationship between music and movement. The artist Robert Rauschenberg designed sets for their produc-

tions. For a time, the artistic trio shared a New York apartment. For the set of his *Rain Forest* (opposite page), Cunningham used Warhol's floating, cushion-like *Silver Clouds*.

No End in Sight

New York City was not only the most important cultural center in the United States, but also the hub of global finance. When speculators discovered Manhattan in the 1980s, countless luxury apartment blocks and huge office complexes were built. Artists moved further to the west downtown, or even to Brooklyn or New Jersey. The smart set moved into neighborhoods where once colorful, creative types had lived. Yet the art scene continued to thrive. The P.S.1 Contemporary Art Center, an affiliate of the Museum of Modern Art, opened in 1971. The gallery owner Mary Boone was a fixed star in New York's artistic firmament in the 1980s. She showed the work of Neo-Expressionist painter Julian Schnabel and represented Jean-Michel Basquiat, whose graffiti paintings were soon in great demand.

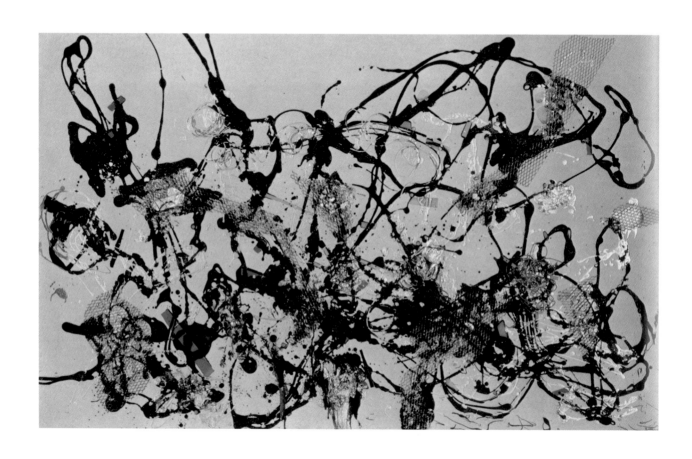

Action Painting Jackson Pollock not only devised a new visual style, but also invented a new painting technique in order to achieve it. He poured, dripped, and splashed his paint on to his large-scale canvases, or "drippings." Depending on the size of the painting, Pollock often had to walk across his canvases, which were laid out flat on his studio floor. Action Painting had entered the world.

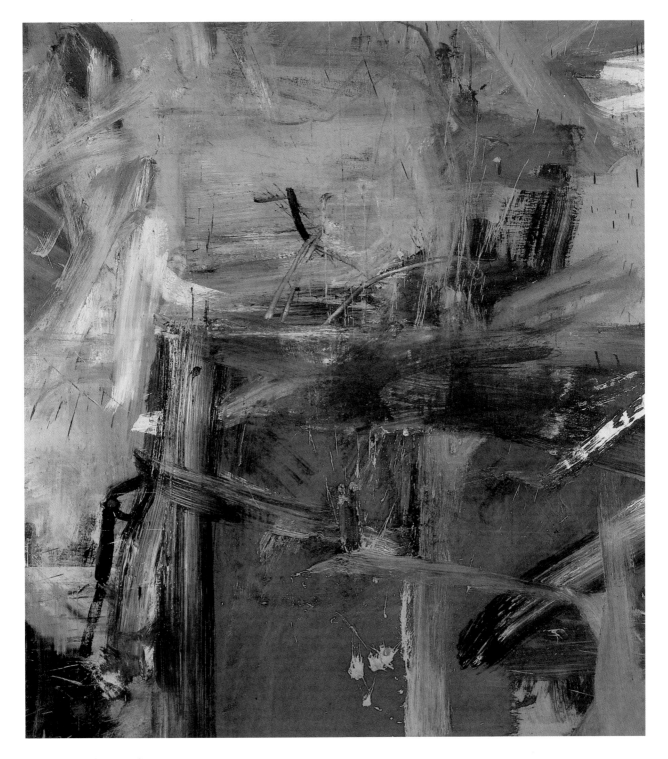

Abstract Expression After Pollock's death, Willem de Kooning became one of the leading artists of the Abstract Expressionist movement. Only the title of his 1957 painting, *Palisade*, reveals his beginnings in figurative art. Broad brushstrokes sweep across a canvas animated by radiant blue.

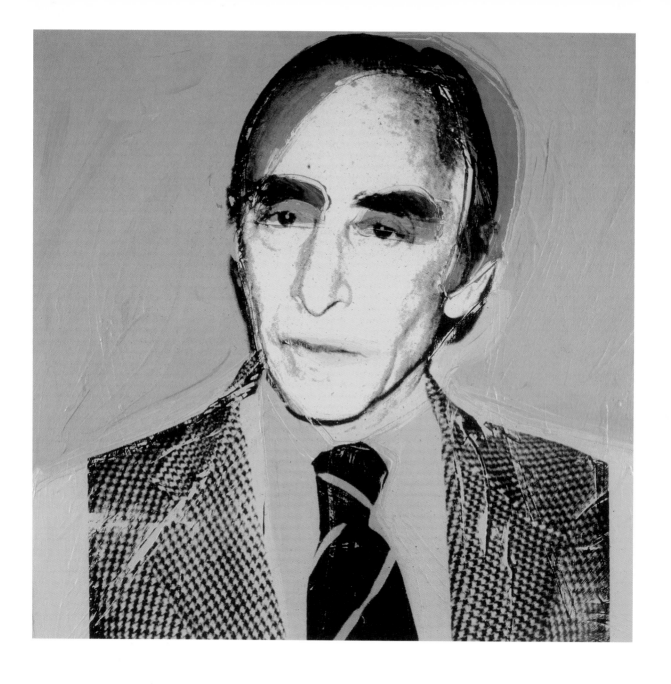

Art Dealer Extraordinaire Here portrayed by Andy Warhol in 1975, Leo Castelli was one of New York's most respected and successful gallery owners for five decades. He organized exhibitions of the work of Pop artists Jasper Johns, Roy Lichtenstein, and Andy Warhol, among others, and helped them on the road to international success.

Young and Untamed Jean-Michel Basquiat covered Manhattan in graffiti before making friends with Andy Warhol, Keith Haring, and other artists. His rapid rise to fame in New York's art scene during the 1970s and 1980s was unparalleled. On his death aged 27, he left behind over 100 paintings and objects, as well as 2,000 drawings.

Fame

"I'm not saying that Andy Warhol has no talent... but I couldn't say just what that talent is—except perhaps in being a genius at selling himself."

Truman Capote

"Making money is art and working is art and good business is the best art."

Through hard work, Warhol early on gained a place for himself in advertising in New York. It took a while before the art world took him seriously, however. When it did, there was no stopping him.

Famous Friends

Warhol didn't just make portraits of countless artist celebrities, he also exchanged work with many of them. In a diary entry in March 1981, Warhol recorded an unusual gift from a fellow artist: "We had breakfast with Joseph Beuys, he insisted I come to his house and see his studio and the way he lives and have tea and cake, it was really nice. He gave me a work of art which was two bottles of effervescent water which ended up exploding in my suitcase and damaging everything I have, so I can't open the box now, because I don't know if it's a work of art anymore or just broken bottles. So if he comes to New York I've got to get him to come sign the box because it's just a real muck."

Andy Warhol and Joseph Beuys in Munich in 1980.

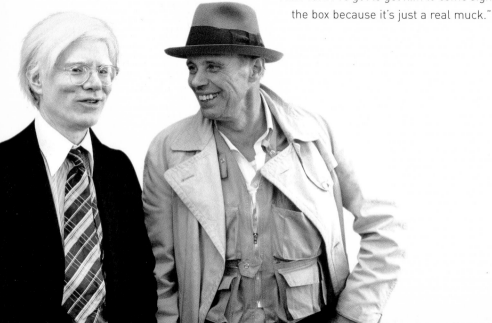

Publicity ...

-→ ... "is like eating peanuts, once you start you can't stop" (this is Warhol describing his addiction to success)

-→ ... was not something Warhol lacked. In fact, he was assured of media attention: his work was radical for its day, he looked eccentric, and he turned up at every kind of social event.

A Theater of One's Own

In the summer of 1968, Andy Warhol was severely wounded when a feminist called Valerie Solanas shot him several times. A flood of good wishes was received at the hospital. The Garrick Theater in Greenwich Village, where he had often shown his films, paid him a very special honor: on 15 July 1968 it changed its name to the Andy Warhol Garrick Theater.

29 Acts in 200 Hours

... was the length of Warhol's sole play, which premiered in 1971 at La MaMa Experimental Theatre Club in New York. The work in question, *Pork*, was based on tape-recorded phone conversations between Warhol and his "superstars," and was essentially a succession of obscenities. The play's title was a pun on the stage name of its leading lady, Brigid Polk (above). The Factory's photographer Billy Name was easily recognizable as Billy Noname. Enthusiasm for the play on the part of the Factory crew was limited, but at London's Roundhouse Theatre the play ran for a year.

"I'm not interested in psychoanalyzing Andy Warhol because I love him too much to do so."

Joseph Beuys

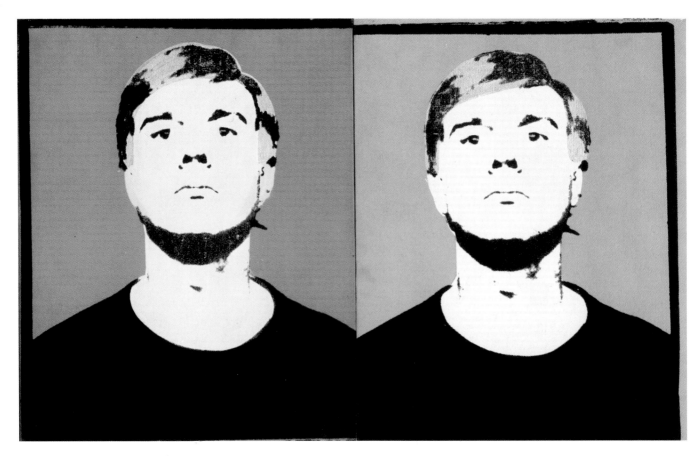

Warhol's fixity of purpose and self-discipline quickly paid handsome
dividends. Even during his lifetime, he notched up a number of retro-
spectives in famous museums, and his work was represented at
major exhibitions worldwide—to say nothing of his financial
success. Two silkscreen self-portraits from 1964.

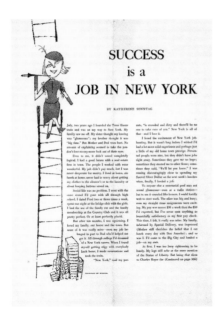

One of Warhol's first commissions in New York in 1949 came from *Glamour* magazine: he was to design an illustration for an article entitled "Success is a Job in New York."

An Artist on His Way Up

Having barely arrived in New York, Andy Warhol started to build up his contacts tirelessly. To begin with, he concentrated on obtaining jobs as an illustrator for glossy magazines. Yet he soon also plunged into the art scene in search of contacts. His diaries now began to bulge with the names of famous artists and gallery owners, and it was not long before the first buyers of his work came along.

Award-winning

Warhol soon became a successful commercial artist and his order books began to fill up with the names of top-ranking clients such as *Harper's Bazaar* and *Vogue*. Still in his mid-twenties, he even collected his first prizes: in 1952 he was awarded the Art Directors Club Medal for his newspaper ads. That same year, he had his first solo exhibition: the Hugo Gallery showed fifteen of his illustrations to accompany texts by Truman Capote, an author he revered. The exhibition was lost amid New York's vast program of cultural events, however, and his illustrations went unrecognized (they are now missing). Other prizes followed, however: in 1954, the American Institute of

> "Everything is beautiful."
>
> **Andy Warhol**

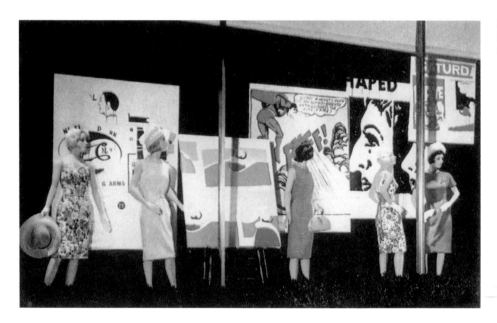

In April 1961 Warhol used his work as part of a window display.

Graphic Arts awarded Warhol its Certificate of Excellence for his achievements in commercial design. Also that year, his work was shown at the Loft Gallery.

Museum Debut

1956 was a special year for Warhol. The Art Directors Club was again in touch, this time with an award for outstanding achievements. Two exhibitions at the Bodley Gallery were topped by a special invitation to show a piece of his work at a group exhibition called *Recent Drawings U.S.A.* that was held at New York's prestigious Museum of Modern Art.

Having already established himself as a commercial artist, Andy Warhol now tried his luck as an artist. Success did not come to him as readily in this field, however. When there were no takers for his comic strips, Warhol used them to decorate a window installation at a Fifth Avenue department store. He did not need to wait too long before interest was shown in his artistic work.

First Exhibitions

What helped establish Warhol as an exhibiting artist in 1962 was what is now possibly his most famous work: *Campbell's Soup Cans* covered the walls of the Ferus Gallery in Los Angeles. Eleanor Ward arranged his first solo exhibition in New York at her Stable Gallery. Her condition was that Warhol would be allowed to hang only pictures of dollar bills. He did, and was rewarded with a great deal of attention. That same year, he was included in the exhibition *The New Realists* in New York's Sidney Janis Gallery. Showing his work alongside that of Claes Oldenburg, James Rosenquist, and Jean Tinguely, this exhibition marked Warhol's breakthrough in the New York art scene. He had made the transition from successful commercial illustrator to Pop artist. In 1964, Ward arranged an exhibition of his *Brillo Boxes* and other wooden objects that reproduced industrial packaging. On this occasion, there was again a lot of publicity, but again financial success failed to materialize and Warhol and Ward ended their brief collaboration.

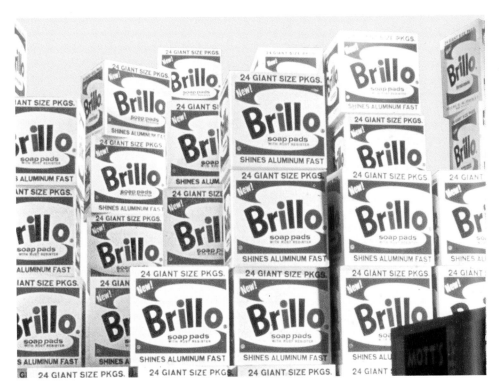

Brillo Boxes in the Warhol exhibition at Leo Castelli's Gallery in 1964.

Europe beckoned instead: in 1964 Ileana Sonnabend showed Warhol's paintings in her gallery in Paris. Warhol sent his pictures of electric chairs to France because he felt they were more suitable than his icons of American consumer society. Around the same time, he received critical recognition for his first film productions, and the magazine *Film Culture* awarded him its Independent Film Award.

Financial Success at Last

Leo Castelli was one of the leading gallery owners in New York in the early 1960s. Warhol was a regular at Castelli's shows, and bought some paintings and drawings from him. Warhol also became friends with the gallery director Ivan Karp who, like Castelli later, tried to sell Warhol's work—albeit hesitantly to begin with. In 1964, Warhol could boast of having a solo exhibition at Castelli's gallery. This was the exhibition that finally brought financial success: it sold out. With bird's-eye views of flowers, Warhol was rather tame in his choice of subject, however. Another exhibition at Philadelphia's Institute of Contemporary Art in 1965 was a special event: because of the expected rush of visitors, the artist's paintings were taken down as a precautionary measure. Warhol commented: "It was great: an opening without art."

International Success

From Paris to Toronto, from Buenos Aires to Turin—requests started coming in from galleries around the world. In 1968, Warhol traveled to Stockholm together with his friends Viva and Paul Morrissey. The city's Modern Museum was showing a major exhibition of his paintings, objects, and films. In 1967 and 1970, his work

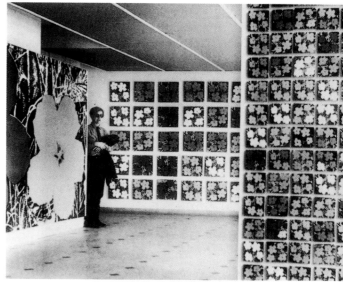

Warhol's first exhibition in Europe was held at the Ileana Sonnabend Gallery in Paris in 1965. On view are works from his *Flower* series (pages 30, 31).

Warhol with fellow artists (left to right) Tom Wesselmann, Roy Lichtenstein, James Rosenquist, and Claes Oldenburg in New York in 1964.

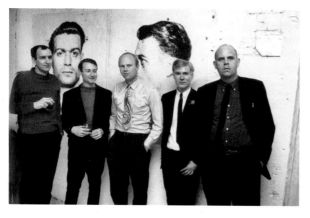

was represented in the US *Expo* Pavilion; in 1968, he showed his work at *documenta 4* in Kassel. Museums around the world were exhibiting his work. In 1970, for instance, the *Andy Warhol* show toured to a number of important museums: the Pasadena Art Museum, Chicago's Museum of Contemporary Art, Eindhoven's Van Abbe Museum, the Musée d'Art Moderne in Paris, London's Tate Gallery, and finally the Whitney Museum of American Art in New York. In 1976, Warhol's drawings from 1943 to 1975 traveled from Stuttgart to Düsseldorf, Bremen, Munich, Berlin, Vienna, and Lucerne. With so many exhibitions on, it was sometimes difficult to keep track of them all. In 1982 in Paris, for instance, Andy was surprised to learn of a show dedicated to him: "At 6:30 I had an opening at the Daniel Templon Gallery which I didn't know I was having but since I was in town I had to go to it. We got there and it wasn't so bad. It was the *Dollar Signs* and they looked pretty good."

Top Dollar

Even in the mid-1960s, Warhol's paintings were celebrated as the sensation of the art market. Following his shooting and the subsequent media blitz (page 75), Warhol became known to yet more people, and his work steadily increased in price. There would still be setbacks, however: the exhibition of his *Dollar Signs* at the Leo Castelli Gallery in 1982 was a flop. Not a single painting was sold, despite the fact that everybody who was anybody showed up at the opening. On 9 January, Warhol wrote in his diary: "Another big opening of mine—a double—*Dollar Signs* at the Castelli on Greene Street and *Reversals* at the Castelli on West Broadway. Bob Rauschenberg was at the opening and Joseph Beuys and Hans Namuth and it was like a busy sixties day. And I forgot how attractive artists are. They really are attractive. The stairs were the best place to stand to see people and sign things. Then went over to the Greene Street thing, and the heavyweights were there." A short while after the *Dollar Signs* failure, prices for Warhol's work rose again, and the number of commis-

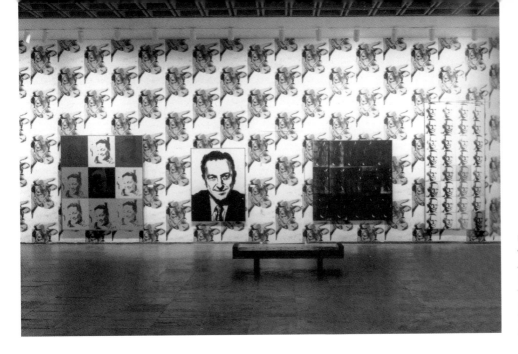

In his own lifetime—he was in his mid-forties—Andy Warhol had the pleasure of seeing his work shown in a major retrospective at the Whitney Museum of American Art in New York.

sions from Europe began to increase. The paintings on which Warhol and the graffiti artist Jean-Michel Basquiat collaborated were received with little enthusiasm, however. The exhibition they shared in New York was not a success. What made things worse was that Basquiat broke off contact with Warhol after a review in the *New York Times* referred to Basquiat as an "art-world mascot."

Multitalented

Such financially disappointing exhibitions were a source of concern to Warhol. After buying a former electricity substation in Midtown Manhattan as a new studio in 1981 for the proud sum of two million dollars, he was beset by money worries. He tried to banish them by keeping hectically busy. He signed up to a modeling agency, and during the 1980s made television and video ads for various companies. He was one of the celebrity guest stars in an episode of *The Love Boat* sitcom. In 1982 he was even given his own show—*Andy Warhol's TV*—on a local New York television station. As in his films, here, too, he worked without a script, and let his guests from the worlds of art and fashion associate freely. In a 1986 MTV show called *Andy Warhol's Fifteen Minutes*, he lived his conviction that, in today's media age, everybody can be famous for fifteen minutes.

Warhol himself was able to extend his fifteen-minute slot considerably, not least thanks to his loyal collectors. The patron of the arts Peter Ludwig talked of "love at first sight" when he discovered Warhol's work in the Leo Castelli Gallery, and he started buying it "in whole series." "His work reflects his time in exemplary fashion: industrial society with its fantastic production of goods, the mass media with their rapid exchange of news of disasters, violence or killing machines, or with their gossip, scandal, and celebrities."

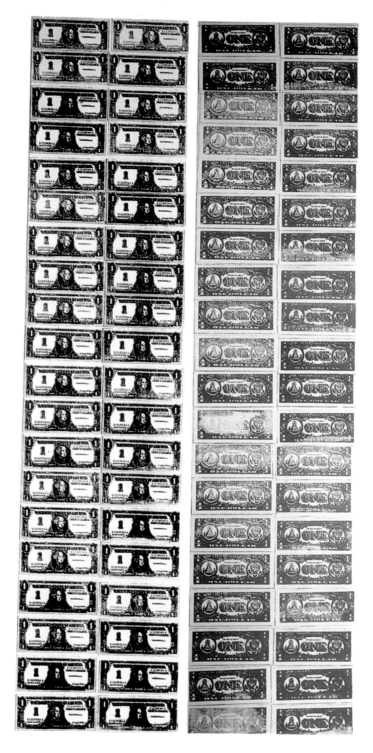

Money as Art "I like money on the wall. Say you were going to buy a $200,000 painting. I think you should take that money, tie it up, and hang it on the wall." This was the view Warhol expressed in his book *The Philosophy of Andy Warhol (From A to B and Back Again)*. At any rate, the value of this silkscreened money increased rapidly.

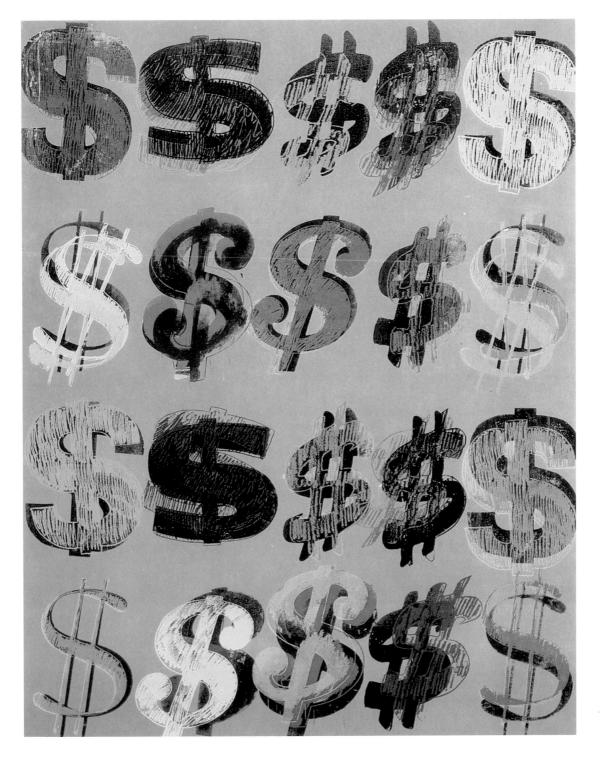

The Art of Money Warhol's *Dollar Sign* paintings and prints found little favor with the critics and public. Leo Castelli exhibited them in 1982, but on this occasion without the hoped-for success.

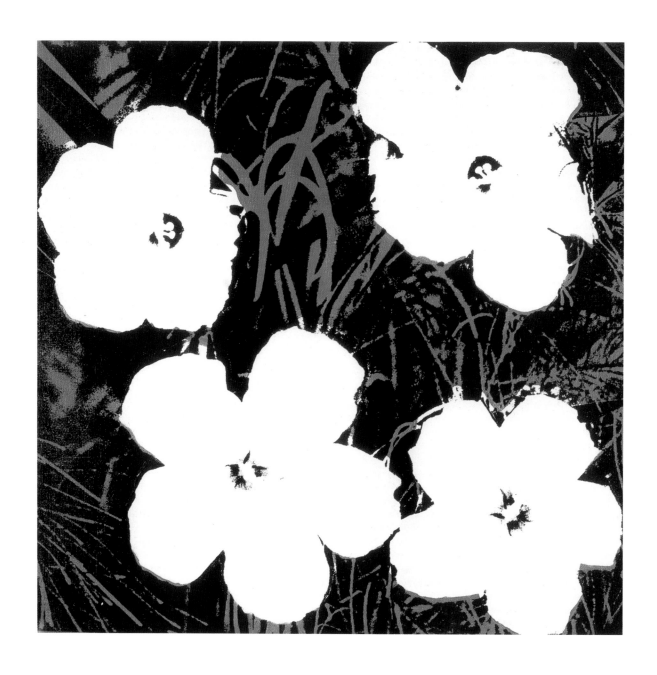

Change of Subject The *Flowers* series was produced after the *Death* and *Disaster* series (for example *Electric Chair*). It was Henry Geldzahler—in charge of contemporary art at the Metropolitan Museum of Art—who suggested Warhol try something with greater appeal.

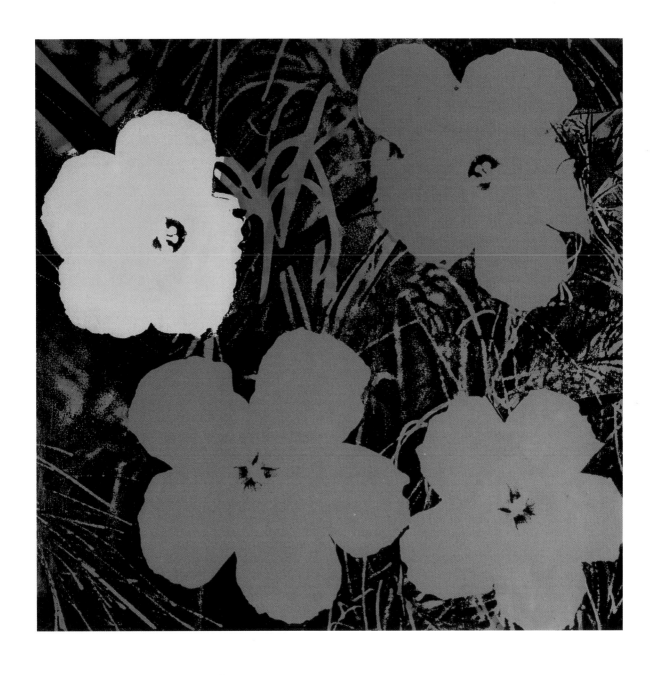

Back to Nature Warhol enjoyed tremendous success with the flower paintings he showed at the Leo Castelli Gallery in 1964, and the show sold out. In search of motifs, this was the first time Warhol turned to a photographic image of Nature: a bird's-eye view of flowers.

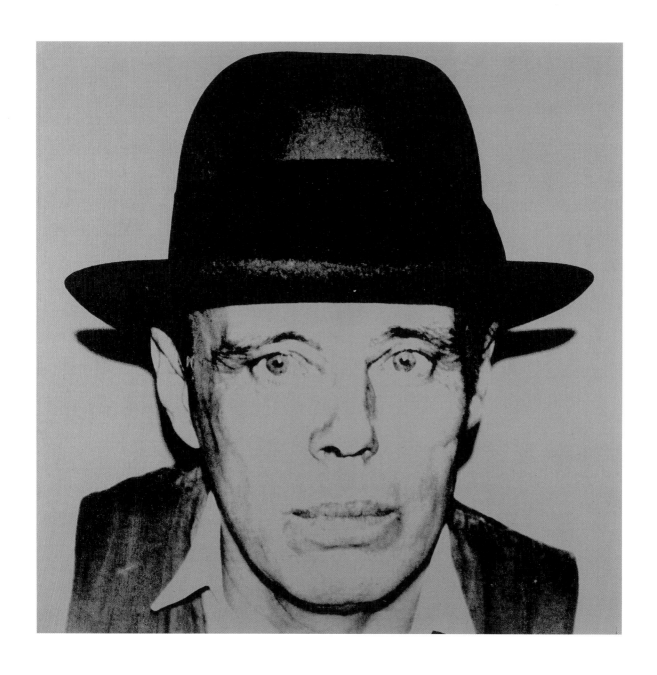

Friends and Foes The German artist Joseph Beuys was a friend of Warhol's. However, not everybody felt well disposed towards Warhol. In the early 1960s, the society photographer Frederick Eberstadt described Warhol as "a skinny creep with his silver wig."

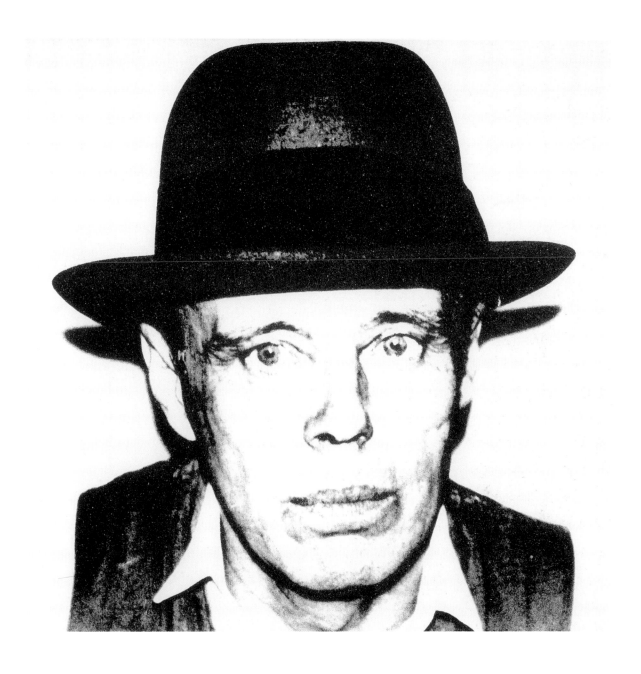

Fellow Artist In the 1970s and 1980s, Warhol produced portraits of everybody who was anybody, including many of his fellow artists (here, Joseph Beuys). He liked to put white make-up on his sitters so that even in front of the camera the effect of two-dimensionality was the same as in the finished portrait.

Art

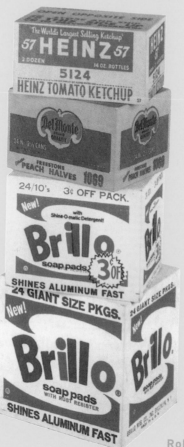

"A good Warhol is possibly not a Warhol at all. There is no such thing as a bad one, though. He is a puzzle to art history. Whether he knowingly sacrificed it, or whether he doesn't give a damn about it, makes no difference. His influence on our lives remains explosive."

Robert Rauschenberg

Dollar bills and car crashes, serial murderers and cans of soup ...

... the list of things that Andy Warhol thought worthy of artistic treatment is very long. Nothing was too ordinary not to be made the subject of his work. With Abstract Expressionism still the order of the day, the art world needed time to appreciate his art.

Pop Art

Pop Art brought everyday life into the world of art: mass media and consumer goods—and criticism of them—lie at the heart of Pop artists' creative work. Store catalogs and commercial art were sources of material, and neon signs inspired its colors. While Andy Warhol painted cans of soup, Roy Lichtenstein enlarged the dotted images of comic strips, and Claes Oldenburg produced giant-size sculptures of household items (page 6) and food. Everyday objects found a new career on both sides of the Atlantic. While the Pop Art movement may have originated in London, it was in New York in the early 1960s that it developed with especial cintidence and vitality.

Packaging also fascinated the Pop artist Jasper Johns, but rather than soup cans, he preferred beer cans!

Titles ...

→ ... are sometimes missing from Warhol's works, and

→ ... the titles he did give his works are often simply descriptive, and not always consistent!

Expressionism vs. Pop

Expressionists—artists who place special emphasis on direct and forceful expression—had already appeared in early 20th-century art, but after World War II new techniques were developed: Mark Rothko and Barnett Newman (right) covered their canvases in large "fields" of color, while Jackson Pollock dripped and poured paint on to canvas laid on the floor to produce so-called "drippings" (page 14). Besides Color Field Painting and Action Painting, still other trends are associated with Abstract Expressionism, which by the 1950s dominated the American art scene and was recognized internationally. It's hard to imagine greater contrasts than those between Abstract Expressionism and Pop Art, which took its motifs from everyday life.

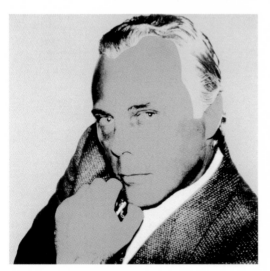

Marilyn and Other Celebrities

Warhol was soon in demand as a portraitist to the Rich and Beautiful. In the 1970s and 1980s, celebrities practically stood in line to be immortalized by him. Were Liz Taylor, Willy Brandt or Giorgio Armani (left) as unlucky with their likeness as Gianni Agnelli of Fiat fame? In 1982, Warhol had to redo the lips on his portrait of Agnelli, causing him to reflect on his technique. In his diaries (which appeared posthumously) he wrote on 28 April: "And I redid the lips on the Agnelli portrait. I wonder what's going to happen to all these portraits in ten years when the little silkscreened dots that make up the image start to flake off."

> "Pop Art is liking things."
>
> Andy Warhol

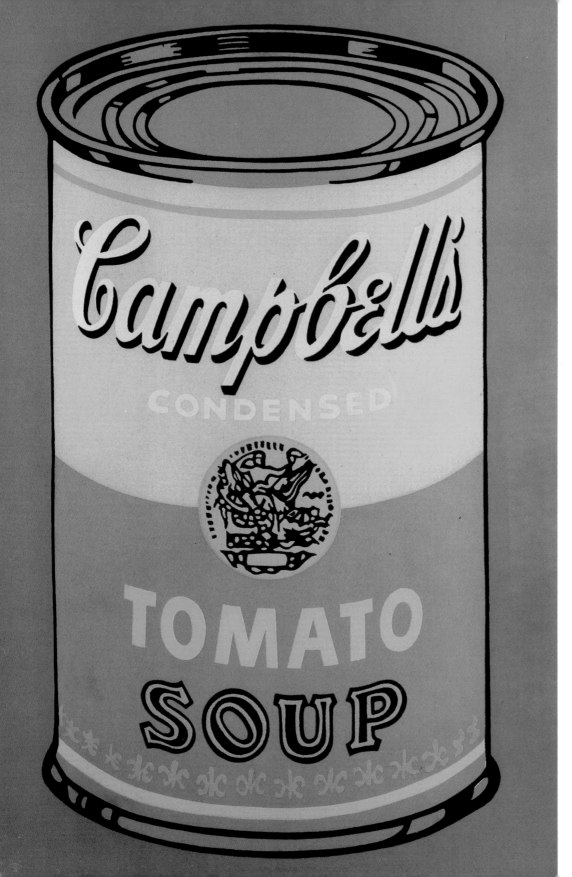

Warhol said he had had Campbell's soup for lunch for almost twenty years. What could be more obvious, then, than making the star in his kitchen the star on one of his canvases? The company even commissioned an advertising poster from Warhol, a trained graphic artist, in the 1980s.

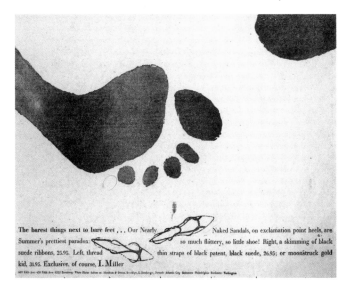

A Warhol design for the shoe company I. Miller published in the *New York Times*.

An Artist of the Everyday

Before he became a byword for Pop Art in the early 1960s, Andy Warhol was far from unsuccessful, and even notched up a number of exhibitions of his work as a commercial illustrator. His meteoric rise as a freelance artist, author, film producer, director, and editor of the magazine *Interview* came about above all because he successfully turned himself into a brand name.

Andy Warhol Enterprises, Inc.

In the 1950s, Andy Warhol earned a living as a commercial artist. Things cannot be said to have been difficult as his work was in demand, and towards the end of the decade he could count himself among New York's best-paid illustrators. His

> I think the less something has to say, the more perfect it is.
>
> **Andy Warhol**

drawings for the exclusive shoemaker I. Miller set standards: it was not the illustrator who conformed to the client's specification, but the client who accepted the artist's originality! It was not unknown for a Warhol shoe to fill the width of a newspaper page but without actually showing the shoe in detail. His ideas paid off, and not only for the shoe company: they ensured Warhol a good basic salary, and even landed him two advertising prizes. His order book continued to fill up, and he designed covers for albums, books,

In 1953 Warhol
also designed
Christmas cards.

wrapping paper, and greetings cards. In 1957, aged twenty-nine, he founded his own firm, Andy Warhol Enterprises, Inc.

It's the Real Thing

Warhol had already had assistants for a number of years. His mother, Julia, often signed his works; Nathan Gluck lent a hand in completing commissions, friends and visitors colored his prints. If need be, a "coloring party" was held: guests were allocated a particular color and told what areas they had to color in—with improvisations allowed. Warhol did not trouble himself over the question of "originality," and for this he was repeatedly criticized.

When it came to numbering the copies of his book *Twenty-five Cats Name* [sic] *Sam and One Blue Pussy*, which Warhol presented to potential clients, he had no qualms about how to number them: as everyone would rather possess a work with a low number, he dished out only works with low numbers! The actual number of signed books—and prints—is unknown.

Mickey Mouse and Superman

In his first tentative steps as an artist, Warhol cited the world of comics. Cartoon characters such as Mickey Mouse, Popeye, and Superman are found in his work around 1960/61. Vintage newspaper ads and commercial art also provided him with many motifs. He quickly discovered silkscreen printing. Its advantage was that it allowed him to work "more like a factory assembly line." In silkscreen printing, an impermeable substance is applied to a fine mesh. When ink or paint is forced through the mesh, only the areas untreated are printed on the underlying support. Warhol discovered that a layer similar to photographic paper could also be applied to his mesh. By projecting an image onto it, the exposed areas hardened and became impermeable while non-exposed areas remained permeable. Ink or paint could then be forced through these areas on to his wooden, paper or canvas support. Before silkscreen printing, Warhol applied a ground of acrylic paint to his canvas to blur the boundaries between painting and printing still further. Even after printing, he would hand-

Acrylic paint and
pastel immortalize
Superman on canvas.

paint most of his work. In 1963, Warhol hired a student
by the name of Gerard Malanga. For years to come, he
would be the artist's most important assistant.

Art and the Gossip Columns

Using the silkscreen process, Warhol transferred every-
thing possible on to canvas, including subjects in ques-
tionable taste: press photographs of accidents and sui-
cides, as well as images of skulls and electric chairs
were produced in series. Warhol said of his *Electric
Chair* series: "You'd be surprised how many people want
to hang an electric chair on their living room wall. Spe-
cially if the background color matches the drapes."
Warhol began to produce portraits of Marilyn Monroe in
many different colors and sizes. Elvis Presley, Liz Taylor,
and James Dean were other subjects he favored. The
newspaper headlines provided him with welcome pegs
for his work: James Dean's early death, Liz Taylor's ill-
nesses and her marriages, Monroe's suicide in 1962.
Warhol exploited anything that the gossip columns had
to offer. That way he didn't have to worry about running
out of material.

Soup of the Day

In our consumer society what counts above all is
money—Warhol made it the subject of a whole series of
works in which he used the now tried-and-tested
silkscreen process to reproduce on canvas dollar notes
in all their glory. American culture is further epitomized
by his images of Coca-Cola bottles.
Towards the end of 1961, Warhol began to produce a
motif that would become one of his most famous: the
Campbell's soup can. Industrially produced and pack-
aged identically, this ready meal was a favorite not only of
Warhol's over many years. His artistic treatment of goods
on the supermarket shelf attracted the attention of the
gallery owner and art dealer Irving Blum, who introduced
the world to Warhol's images of soup cans in his Ferus
Gallery in Los Angeles in July 1962. The thirty-two *Camp-
bell's Soup Cans* are identical except for their labels: on
show was Campbell's complete range of soups.

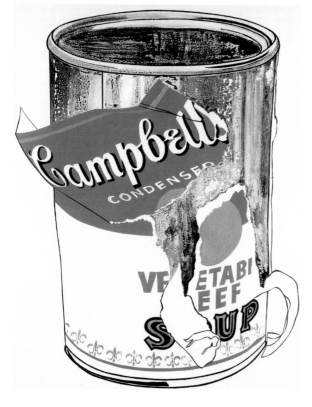

An endless supply of soup cans: Warhol has Campbell's soup to thank for one of his most famous images.

In another development, Warhol began to exhibit industrial packaging. His boxes stole the show when they were exhibited at the Stable Gallery in 1964. Brillo pads or Heinz ketchup, Del Monte peach halves or Campbell's soup: everything was packaged in boxes, and Warhol exhibited them—or rather painted and silkscreened wooden replicas of them.

But such everyday, familiar motifs, repeated ad infinitum, did not immediately strike the right note with gallery owners, let alone collectors. When Warhol first exhibited his box sculptures, buyers were in short supply. There was no lack of critics, however: Was it art or just advertising?

Factory Work

Such criticisms did not curb Warhol's zeal. His crew continued to grow, even if Gerard Malanga remained the sole paid employee. In 1965, Andy and his assistants moved into a loft on 47th Street. Warhol's cohort Billy Name (real name Billy Linich) named it the Factory. It quickly developed into a meeting place for New York's artists: actors, musicians, and painters all came and went in a constant stream. Billy took charge of decorating the place: everything, from the photocopier to the bathroom, was painted silver, the walls were covered in aluminum foil. Warhol loved it. He was always open to novelty, whether it was in interior design or art techniques.

Exploding Plastic Inevitable

In 1966, at the Leo Castelli Gallery, Warhol created the installation *Andy Warhol's Living Room*. Its walls were decorated with "cow wallpaper," and silver balloons served as cushions: filled with helium, they floated around freely. Art and life were again combined.

It was not only installations that enthused Warhol; he also discovered "happenings," in which art, music, and theater converged beyond the boundaries of genre and technique. His enthusiasm reached new heights when he came across the group *The Velvet Underground*. He allowed the colorful band to rehearse in the Factory because the level of noise they produced was so great they

Andy Warhol showed his helium-filled cushions and his "cow wallpaper" at the Leo Castelli Gallery in 1966.

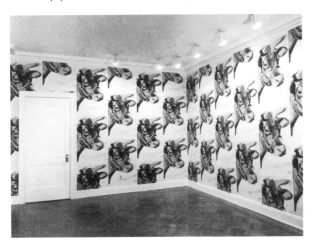

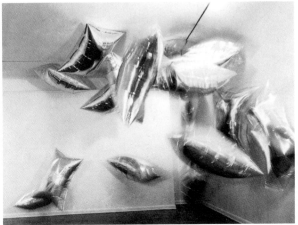

had had problems finding rehearsal space. Warhol became the band's manager, and turned their gigs into happenings with impressive light shows, film projections, and deafening rock music. *Erupting* then *Exploding Plastic Inevitable* was what he called these shows, to which he happily added dancers from the Factory. Gerard Malanga and Edie Sedgwick moved their bodies suggestively.

Film Art

A big fan of the movies, Warhol purchased a 16mm film camera in 1963 and directed numerous films in the decades that followed. His portrait of the Empire State Building was sensational: lasting eight hours, *Empire* shows the building between dusk until late at night in an uninterrupted shot. A fixed camera focusing for hours at a time on a single object or action, with no edits, was a trademark of Warhol's first films. In *Sleep*, Warhol shows the Beat poet John Giorno asleep. The protagonist in *Eat* is Warhol's fellow artist Robert Indiana; he is shown eating a mushroom for forty-five minutes! His

movie ****** *(Four Stars)* is impressively long at twenty-four hours, and it was shown in full only once; thereafter it was edited into segments of varying length.

According to Warhol, it was a simple matter of who did what around the camera: "Whoever switched the camera on was the director." Similarly, those who found themselves in front of the camera became actors. The 1967 film *The Chelsea Girls*—part black and white, part color—shows Factory regulars living in the legendary Chelsea Hotel, a run-down hotel very popular with artists, writers, and musicians in the Chelsea neighborhood of Manhattan. Drug abuse, mental disorders, exhibitionism, and eroticism are the order of the day: it's pure New York underground. There was a screenplay, but it was barely followed: "Everybody joined in and did what they always did: they were themselves ... in front of the camera." The film was a hit.

Superstars Galore

Warhol's films reached a still bigger audience after 1968. After being shot by the feminist Valerie Solanas

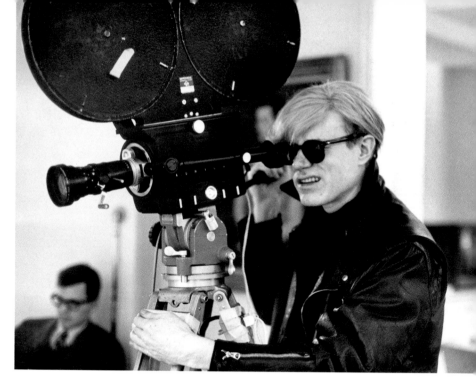

Warhol filming in New York in the 1960s, photographed by Billy Name.

(page 75), Warhol largely left film direction to Paul Morrissey. In contrast to Warhol's experimental films, films like *Flesh* and *Trash* were shown across the United States and Europe. *Blue Movie* shows a couple spending an afternoon in bed, sleeping, eating, talking ... It never had a chance to be successful as New York authorities confiscated it on account of its obscenity only a week after it opened in 1968. Warhol was outraged, as was his superstar Viva, who was in the film.

Warhol was having a dig at Hollywood by calling his actresses "superstars." His superstars were different. One of the first was Edie Sedgwick, a model who was always ready for a bit of scandal. She and Andy went from party to party one year, occasionally in matching clothes. To match the color of Warhol's shock of hair, Edie sometimes dyed her hair silver. Besides Edie, who also appeared in Warhol's happenings, Jane Holzer, often known as "Baby" Jane Holzer, was another important figure. She belonged to New York's smart set, quickly felt at home in Warhol's Factory, and appeared in many of his films.

From Pop to Abstraction

Life at the Factory changed following the shooting. In his art, Andy Warhol opened himself up to new possibilities. In several series, he did away with advertising and art historical motifs altogether. Compared with his other works, his abstract art is still less well known, but the *Shadows*, *Egg*, and *Yarn* paintings he produced between 1978 and 1983 also have their appeal. Warhol also made use of the inkblot technique developed in Rorschach personality tests, and experimented with camouflage patterns that were used in some self-portraits and other works. Yet another group of abstract works are the *Oxidation Paintings* in which he and others urinated on to canvas covered with metallic paint that then oxidized. Rather more refined than these "piss paintings," as they were called in the Factory, is the series of Joseph Beuys portraits. Among other materials, they were made with diamond dust.

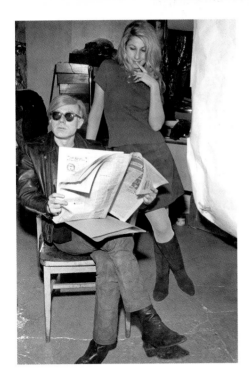

Andy Warhol with
his "superstar"
Jane Holzer, 1969.

Portraitist to High Society

In the 1970s and 1980s, Warhol was more in demand than ever before. He churned out portraits of everyone who was willing to pay him the appropriate fee, and portrait painting now became his main source of income. He had already worked tirelessly as a photographer, documenting everything and everyone with his Polaroid camera. His approach with his prominent and wealthy clients was always the same: first he took various portrait shots of them, then he enlarged the desired image for silkscreen printing. When working on the background, Warhol sometimes took more, sometimes less, care: "It's quicker to work and be messy than it is to work and be tidy." Among other places, he acquired clients at Studio 54, but it was not only the leading lights of New York's nightlife whom he immortalized on canvas. There is a seemingly endless list of individuals whose portraits Warhol painted, often without commission or permission, including Muhammad Ali, Truman Capote (the author he idolized), rock stars like Prince and John Lennon, and even Princess Diana.

A Leonardo for Our Time

Warhol's last large-scale work was his treatment of Leonardo da Vinci's *Last Supper*. He had already dealt with the Renaissance artist's *Mona Lisa*. In *Thirty Are Better Than One*, Warhol replicated the world-famous lady's smile on canvas thirty times. His *Last Supper* developed into a vast series of more than one hundred paintings executed in a number of techniques.

When you are on the East side and fill the need of a hotdog, the following is recommened; take the Lexington ave local to 42 nd St. suttle across to Time sq. Transfer to the D train. Stay on the D train

until you arrive at Coney island. walk 1/2 Block to the left and get on the No 3 Bus. get off the left and get on the bus ot South st. and walk 2 blocks south and one block west, you will then be ot nathans. Order a nathan's special with everything and take a Cab back to manhattan, *

* recipe by Suzie Frankfurt, andy Warhol

Offprint One of Warhol's best-known graphic techniques is the "blotted line." It is achieved when a print is made from an ink drawing, the mirror image result being a print made up of broken lines. Warhol then reproduced prints like this using the offset printing process.

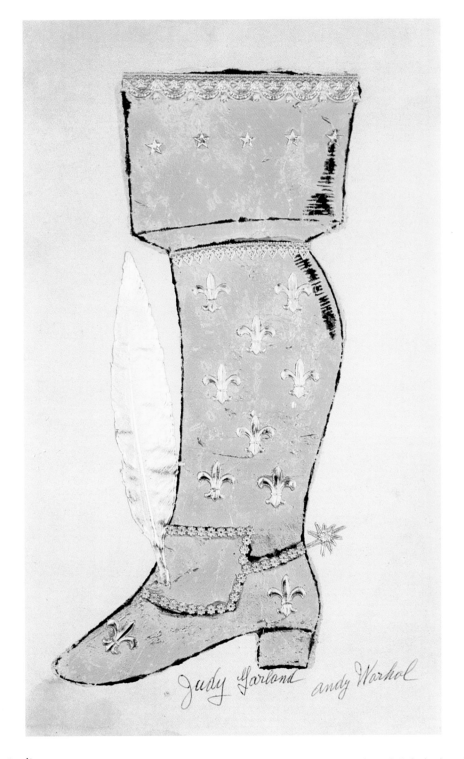

Unusual Portrait Warhol drew all kinds of shoes. In this unconventional portrait from 1956, he shows Judy Garland as a boot decorated with gold leaf fleur-de-lys. Warhol's mother Julia signed the picture with a flourish.

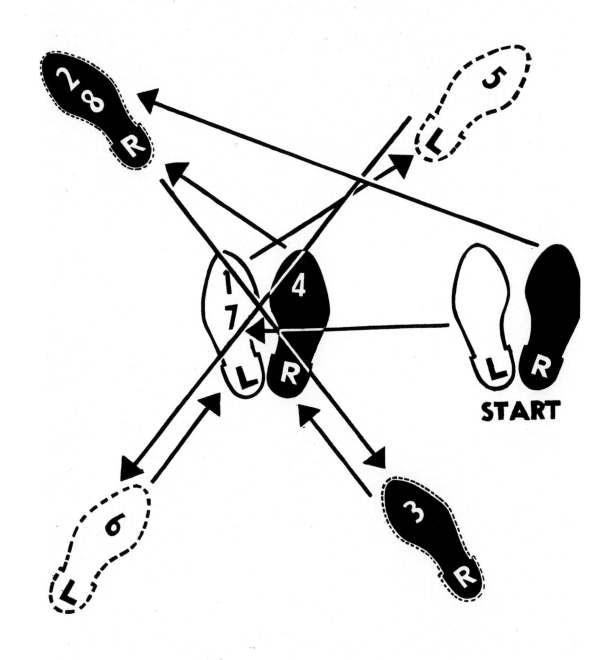

Step by Step Another Warhol series was based on reproducing black-and-white dance step instructions. This 1962 image illustrates the steps of the foxtrot.

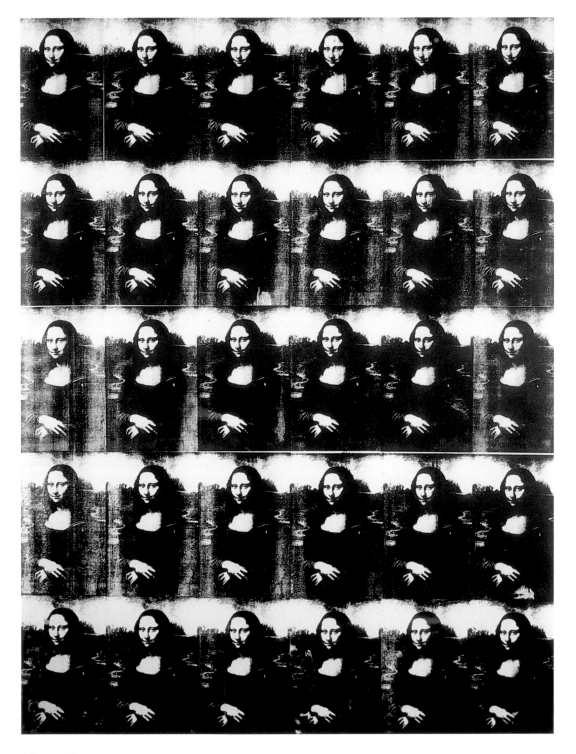

Mona Lisa x 30 Leonardo da Vinci's *Mona Lisa* fascinated Warhol. Here he is clearly of the view that *Thirty Are Better Than One.*

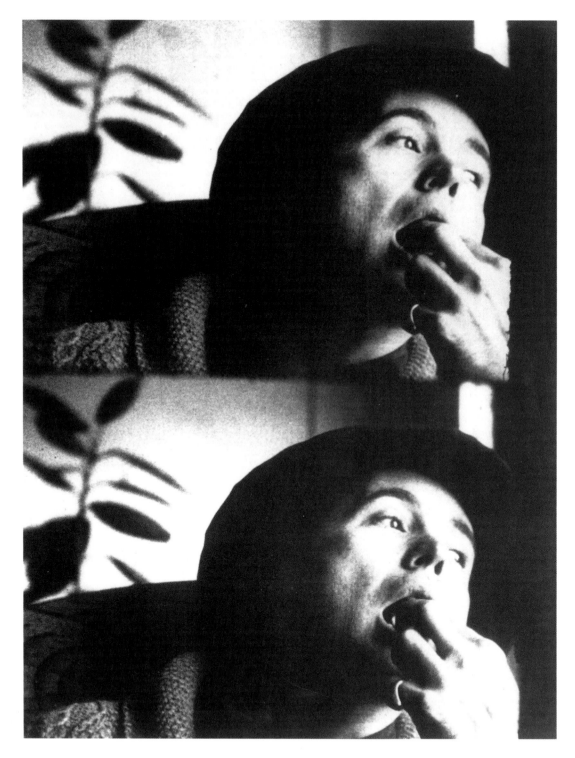

Experimental Artist Robert Indiana savors a mushroom in Warhol's film *Eat*, 1963. There is no need to hurry it: despite its very simple plot, the film still lasts forty-five minutes. Concentration on detail is the main feature of Warhol's experimental films from the 1960s.

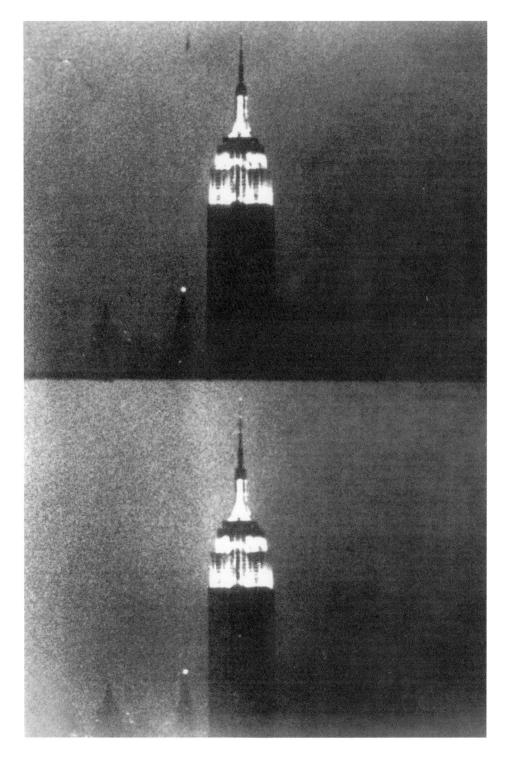

Unconventional Warhol's 1964 film *Empire* is a challenge for viewers. In a single shot lasting eight hours, the Empire State Building is observed from sunset until well into the night.

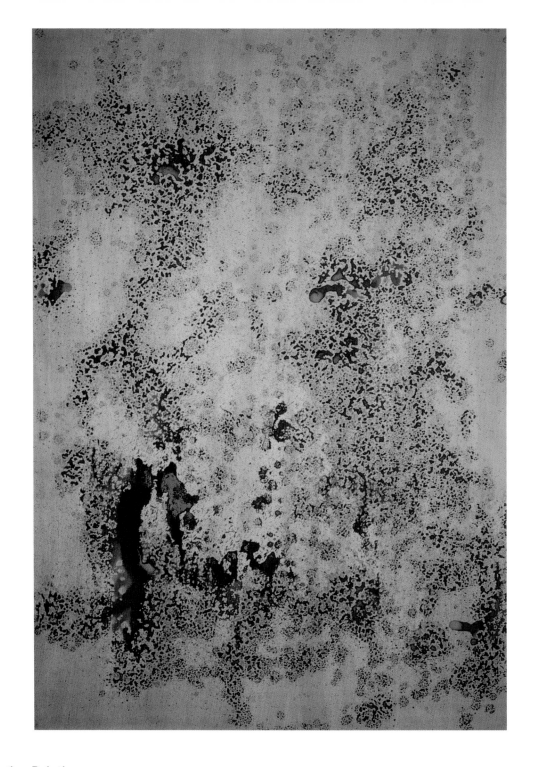

Oxidation Paintings The technique employed here was described as a "combination of materials on metallic paint." Produced by the oxidation of urine on metallic paint, such works were also known in the Factory more prosaically as "piss paintings."

Enigmatic *Shadows* is a large-scale series of abstract works. With little connection with the artist's earlier work, they are something of an enigma. Questioned about them, he replied in his usual monosyllabic and evasive fashion: "These paintings are not for sale."

Shadow Play Shadows cast by different objects in the Factory prompted Warhol to make a series of differently colored paintings. He also toyed with the expectations of potential clients in other abstract work, including the *Oxidation Paintings* (page 52).

Disco Décor Warhol's comments about his *Shadows* series are as enigmatic as they are laconic: "Someone asked me if they were art, and I said no. There was a disco at the opening party, so I suppose that makes them disco décor. This exhibition will be the same as all the others. The reviews will be bad—I always get bad reviews—but the party will have gone down well."

Life

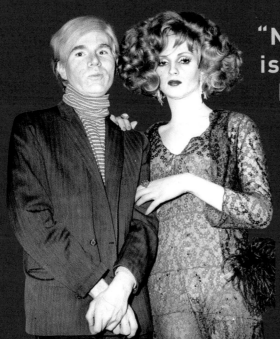

"Nothing about Andy is like anyone else, because Andy was and will always be the first real plastic man ... A plastic man is essentially a robot ... He's pleased when someone describes his work as synthetic. Will Andy be the first robot to be admitted to heaven?"

Isabelle Dufresne
alias Ultra Violet

Quiet, shy, and sometimes unapproachable...

... is how the people who sat for Andy Warhol described him. He certainly doesn't look particularly happy in the numerous photos that exist of him. Most of his day was spent working; the party circuit came second, but when he partied, Warhol took his camera and tape-recorder with him—and was always surrounded by his superstars.

Party Animal

"Party" is one of the words that most often crops up in Warhol's diaries. Whether morning, noon, or night—no matter who was invited, no matter who the host, or the venue—not a day went by without Warhol being invited to a party. Whether it was to Eddie Murphy's birthday party in Studio 54, fashion shows or previews, or dinner with Richard Gere, Warhol and Co. rarely let an opportunity to party pass them by. A good few miles were clocked up traveling the streets of New York, and Warhol kept a careful note of the taxi fares for his diary.

Who'd called ...

-→ ...and who hadn't? Warhol meticulously recorded who did and did not call him: "Not one phone call. That's what happens after being a big star the night before, not one person called all morning," he noted after a big opening at the Castelli Gallery on 10 January 1982.

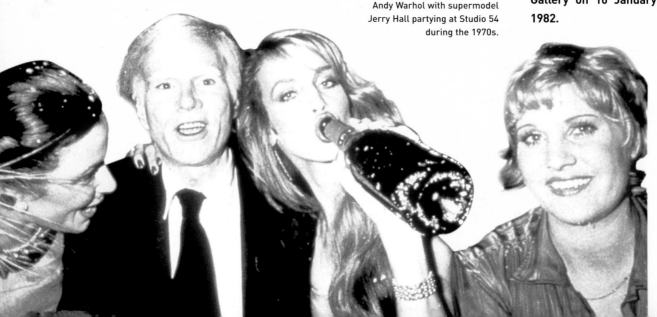

Andy Warhol with supermodel Jerry Hall partying at Studio 54 during the 1970s.

Andy Candy

All at once, a bag from Brownie's health-food store became Warhol's constant companion. Chocolate and other sweet things were always his preferred food

> "But I didn't get married until 1964 when I got my first tape recorder. My wife. My tape recorder and I have been married for ten years now. When I say 'we', I mean my tape recorder and me. A lot of people don't understand that."
> Andy Warhol

(which is why the gallery owner Eleanor Ward nicknamed him Andy Candy). Following his shooting by Valerie Solanas, however, and a subsequent operation, Warhol had to keep to a special diet. Brownie's health-food store on Fifth Avenue and Union Square was where he went to buy his groceries every day. When out shopping along Madison Avenue, Warhol not only saw to his physical well-being, but also tried to convince storekeepers to advertise in his magazine, *Interview*.

Weight Watching

Warhol's sweet tooth meant that keeping his ideal weight became an increasingly difficult task. Judging by his diaries, he seems to have paid close attention to his pounds, however. In the 1980s especially, infected by society's growing fixation on fitness and youth, he worked out hard. He discovered bodybuilding, and at first engaged in it as excessively as in his work.

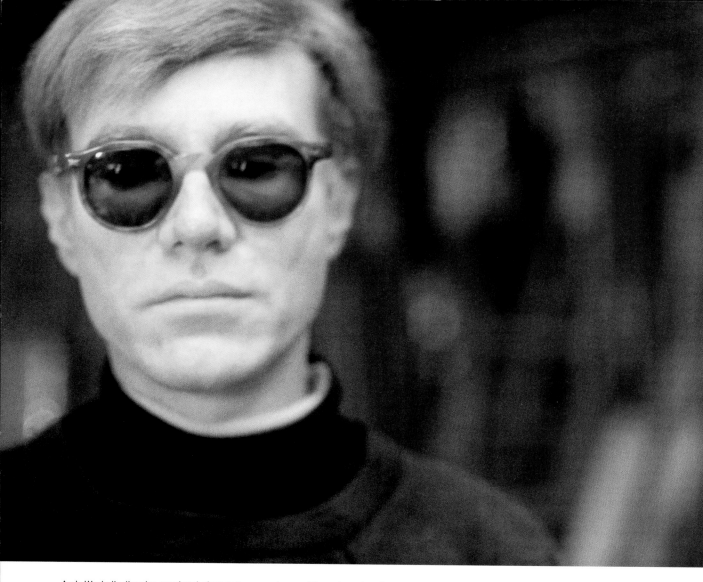

Andy Warhol's disguise consisted of more than sunglasses. His preferred outfit while out and about in Manhattan was a black turtleneck sweater, jeans, and a leather jacket. A silver wig completed the look.

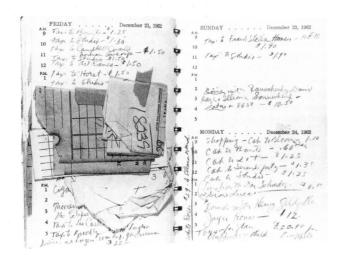

Andy Warhol's diary. December 1962 appears to have been quite busy!

Work First, Party Later

Andy Warhol liked to play down his age. To give the impression of being younger, he sometimes claimed he was born in 1930; at other times he even said he was born in 1933. At least his place of birth stayed the same: the superstar first saw the light of day in Pittsburgh, Pennsylvania.

Slovakian Roots

His actual date of birth was August 6, 1928, and he was named Andrew Warhola, the youngest of three brothers. Not much is known of his childhood and youth. His parents, Julia Justyna and Ondrej Warhola, had emigrated to the United States from the village of Miková in the Carapathian Mountains (present-day Slovakia). Andrew's father found work with a construction company in Pittsburgh, where the family became part of the city's Uniate community (those Catholics of Eastern Europe who retain their own liturgy). Warhol appears to have been religious, although the evidence is contradictory. He once claimed that the

> "In the sixties there was always a party somewhere. If there wasn't a party in the cellar, there was one on the roof, in a subway, on a bus, on a boat, in the Statue of Liberty."
>
> **Andy Warhol**

The Warhola brothers
Paul (left), Andrew, and John (right)
in Pittsburgh, around 1942.

Andy (right) and his
mother Julia and
brother John, around 1931.

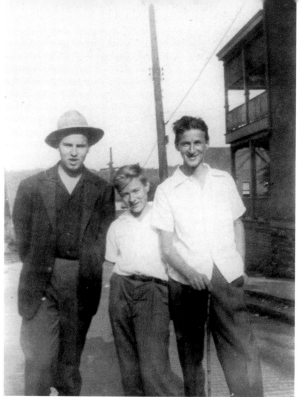

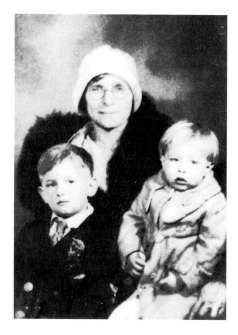

thing he liked best about churches was their emptiness. It remains open to question whether that was the sole reason why he visited them.

Drawing and Movie Stars

Andrew was fourteen and at High School when his father died; with his fear of hospitals, Ondrej had for months refused treatment for jaundice. It now fell to Andrew's brothers, Paul and John, six and three years older than him respectively, to ensure the family's livelihood. John sold fruit and vegetables in the city's working-class neighborhoods. Andrew went with him.

Several times as a child, Andrew suffered from a hereditary illness of the nervous system, and as a result of a rare pigment disorder his skin and hair were white. He often had to spend weeks at a time in bed. His mother, Julia, gave him comics and coloring books. "She'd give me a Hershey Bar every time I finished a page in my coloring book." Andrew's enthusiasm for drawing grew by the day—as did his liking for confectionery. When questioned in later life about the first piece of art he made, he mentioned the paper cutouts he produced around this time.

Andrew's gift for drawing was spotted by his teachers even when he was at elementary school. He was allowed to attend the art courses that the Carnegie Museum of Art run for gifted children. At High School, Andrew discovered another passion: the cinema. Shirley Temple's autographed photo marked the beginning of what would become a considerable collection of movie memorabilia. His enthusiasm for Liz Taylor, Marilyn Monroe, and other celebrities would later find expression in countless portraits.

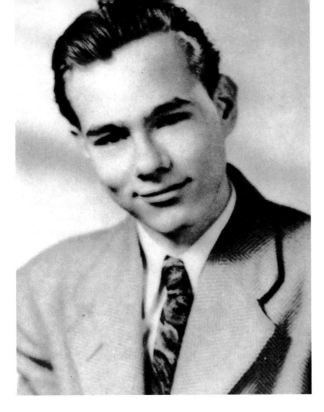

Andy Warhol in
shirt and tie,
aged about seventeen.

First Commissions

From the fall of 1945, Andrew spent four years studying pictorial design and the history of art at the Carnegie Institute of Technology in Pittsburgh.

On graduating, he moved to New York City with Philip Pearlstein, a fellow student who would also become a major artist. In an interview with Glenn O'Brien, Warhol later recalled their far from glamorous start: "Philip Pearlstein wanted to travel to New York during the semester vacation, and I took along a shopping bag and we took the bus. We took our portfolios and showed them around in New York to see if we could get jobs." Tina Fredericks, the art director at *Glamour*, liked Warhol's work, and he started to work for her freelance: his first job was to make drawings of shoes. Very soon, *Vogue*, *Harper's Bazaar*, and *The New Yorker* were among his clients. When he was still in his twenties, Warhol had his work exhibited twice, and in 1956 his drawings were even shown in New York's Museum of Modern Art.

Roommates

Warhol's first few years in New York City were certainly no picnic as canvassing for custom took time and energy. Having little freetime, it was mostly at night that he found peace and quiet to work: "My life in the 1950s looked like this: greetings cards and watercolors and now and then a poetry reading in a café." It's said that Warhol did not turn down a single offer—he even ventured to tackle recipes! In 1959, collaborating with a designer called Suzie Frankfurt, he produced a satirical recipe book entitled *Wild Raspberries*. Hand-colored drawings and satirical texts made fun of strict adherence to recipes. Use Warhol's recipe and you will end up with "Strawberry Shoe" or "Omelet Greta Garbo." Suzie Frankfurt made no secret of her own culinary skills: "I had two left hands when it came to cooking, and that's how our cookbook came about …"

Warhol and Philip Pearlstein, who continued his studies at New York University, had drifted apart in the meantime and no longer lived together. Warhol moved into a basement apartment on 103rd Street at Manhattan Av-

A cake from Warhol's satirical *Wild Raspberries* cookbook, which he produced in collaboration with the designer Suzie Frankfurt.

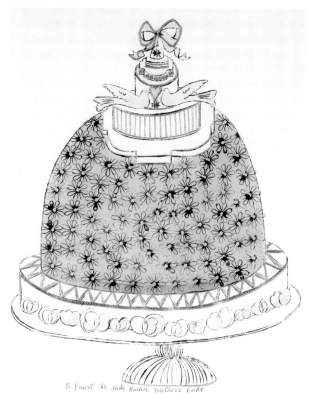

To Ernst he Andy Warhol mother's cake

enue. Although the apartment was in the smart Upper West Side, conditions were far from luxurious: as many as seventeen people lived in it! But commercial art proved to be a flourishing business and Andy, as he now styled himself, was soon able to move into an apartment of his own for the first time. It was located on Manhattan's East Side, at 75th Street and 3rd Avenue. This apartment he shared with a number of cats—whose job it was to keep down the huge numbers of mice—and a television. Warhol's favorite program was the news. It was important to know who was doing what.

Creating the Right Image

Rather than as a commercial artist, Warhol wanted to establish himself as an independent artist in New York. He made a great effort to carve out his own particular artistic niche, and constantly sought contacts with the gallery scene. In the fall of 1960, he moved to 1342 Lexington Avenue. He took his cats with him, of course; to simplify matters, his four-legged companions were all called Sam. Having moved away from Pittsburgh, his mother Julia also shared the apartment. A disused ladder factory nearby served as his studio for a few months. In the meantime, he had started to work on oversize canvases that required a big workspace. And of course an artist needed the right outfit: during subsequent decades, Warhol preferred to show up wearing a black turtleneck sweater, jeans, and a leather jacket. His dark sunglasses, and later also his silver wig—he acquired his first hairpiece when he was only twenty-five—completed the picture. Many described him as absent-minded and reserved. When engaged in conversation, Warhol knew how to keep people at a distance with replies of one syllable, and by answering a question with a question. Invitations to give public lectures at universities he avoided altogether. Instead, he sent a look-alike called Allen Midgette dressed in the Warhol look, complete with toupee. According to Warhol, Midgette was a far better speaker than he was himself.

"Baby" Jane Holzer in Warhol's 1964 black-and-white silent film *13 Most Beautiful Women*.

Factory Work

He needed an audience for this show, of course, and the right location. In late 1963, Warhol moved into a spacious studio in Midtown Manhattan. Located at 231 East 47th Street, it was dubbed "the Factory." A colorful group of people was soon at work there on a wide variety of projects. This studio, and others over the next few years (which were also called the Factory, not only served as a place in which to make art and films, but also offered living space—measuring about 4,000 square feet, the fifth-floor loft was large enough.

New faces turned up every day. At the center of them all was Andy Warhol, documenting everything and everyone with his film camera. No visitor was safe from him, and everyone was asked along for a test shoot. Warhol left behind hundreds of such *Screen Tests*, which all had the same format: the subject sat down on a chair amid the glare of lights. Warhol switched his camera on and left the room. The film ran for three minutes. The reactions of those left alone in front of the camera are as different as they are fascinating. It seems that Warhol's obsession with his camera did not stop anybody from visiting the Factory: Bob Dylan and Jim Morrison came by, the artist Marcel Duchamp looked in, as did Salvador Dalí. Actors, dancers, transvestites, would-be celebrities, artist friends, junkies, and musicians filled the rooms. In February 1968, the Factory moved into the sixth floor of a building on Union Square West, but soon also took over the eighth and tenth floors.

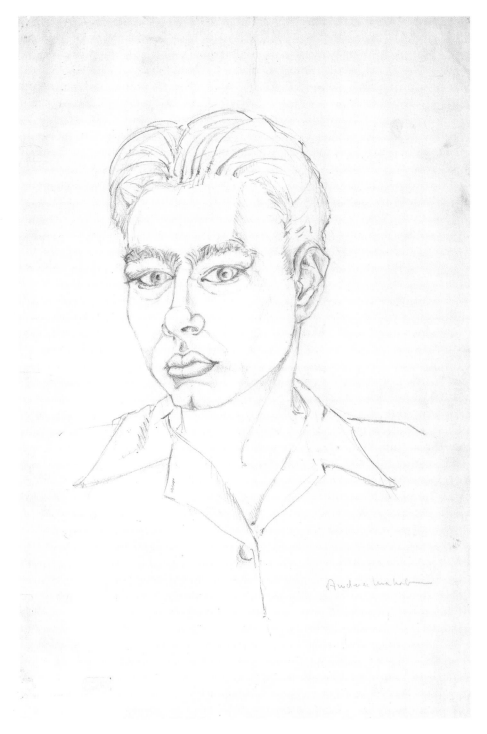

Mirror, Mirror Andy Warhol (then still Andrew Warhola) drew this self-portrait when he was still a high-school student. In 1942, he had yet to discover the silkscreen technique; here his likeness is captured in pencil.

Close-up "Andy Warhol appeared to abolish the alienation between the artist and society, between civilization, art, and consumer society. He dreamed of a peaceful, instinct-free, meaninglessly lovely and apathetic art-life that—in place of Communism that he early on declared to be unnecessary—could make everyone equal and turn them into happy consumerist automatons." Edouard Beaucamp, 1982.

Canvas Comic Andy Warhol developed his love of comics as a child. Even decades later, he appears not to have lost it entirely. He produced this acrylic-on-canvas painting of spinach-loving Popeye in 1961.

Cult Figure The American comic-strip figure of Nancy was familiar not only to children. She is, in fact, one of the most successful and longest-running comic-strip figures in the 20th century. Her adventures were reproduced daily in countless newspapers. For Warhol, brand recognition was important.

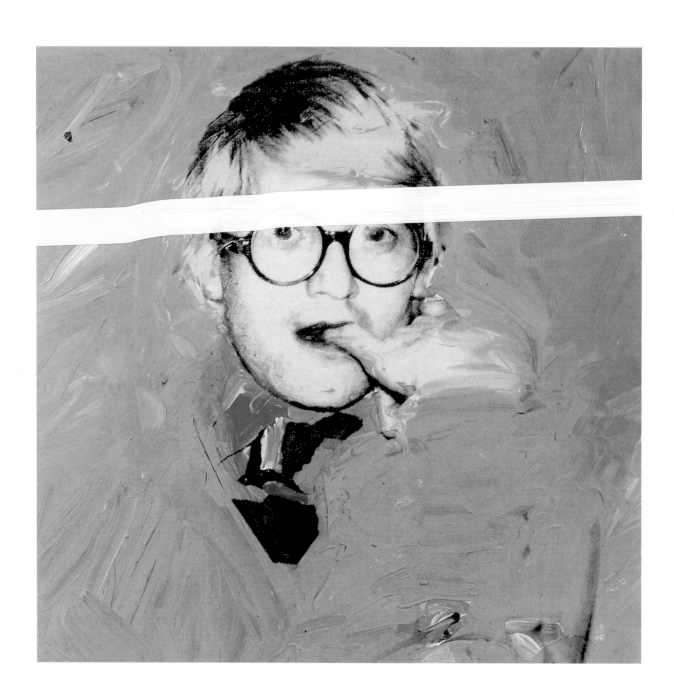

Water Colors Warhol produced this turquoise portrait of the British artist David Hockney in 1974. The choice of color is probably no accident: Hockney had made his name with a series of oil paintings of Los Angeles swimming pools in all shades of turquoise.

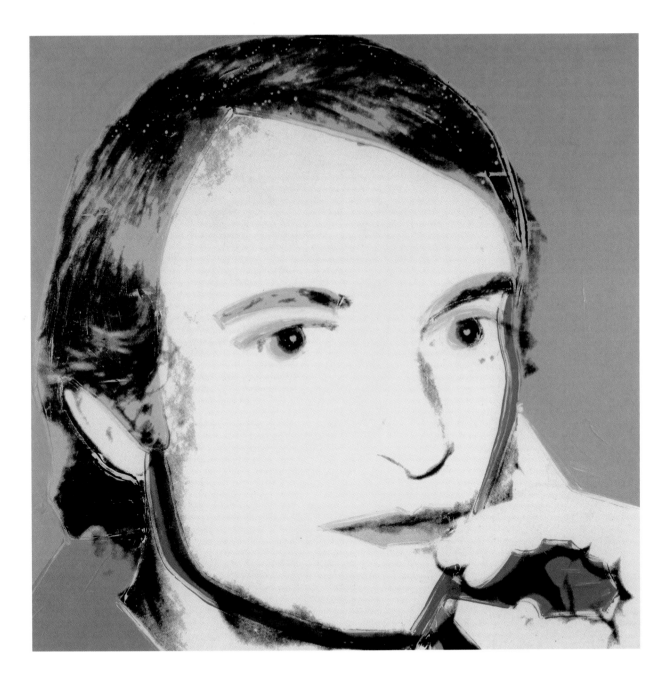

Fellow Traveler The vastly enlarged comic strips exhibited by Roy Lichtenstein at the Leo Castelli Gallery in 1961 probably inspired Warhol. He produced this portrait of Lichtenstein in typically close-up fashion in 1976.

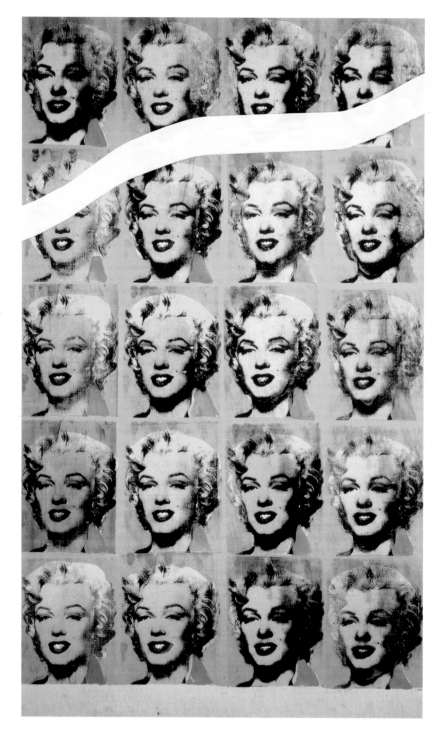

Film Icon Whether lilac on orange or black on green, Warhol's images of Marilyn Monroe are among his most famous series of portraits. In countless versions he shows a smiling peroxide blonde. Warhol also used the famous still from the film *The Seven Year Itch* as a model for his take on this film icon.

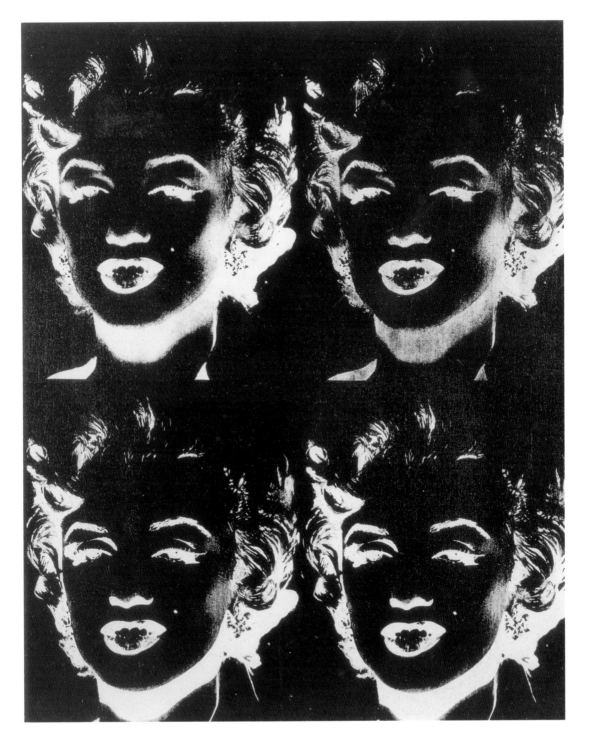

The Stuff of Legend Marilyn Monroe was only thirty-six when she died in Los Angeles in 1962. Myths surrounding her began to develop immediately, and numerous conspiracy theories about her death were in circulation. The newspapers could not print enough about her tragic fate. Neither could Andy Warhol.

Cover of the 1975 edition of *The Philosophy of Andy Warhol* (below), and the cover of the posthumous diaries (right).

A Harvest/HBJ Book

"By the way, does the diary know ..."

Published in 1967 by Warhol, Stephen Shore, Nat Finkelstein, and Billy Name, *Andy Warhol's Index Book*

offers a glimpse of life at the Factory. Starting in the mid-1960s, Warhol kept his fellow worker Pat Hackett informed by phone about everything that was going on in his life. He filed his diary-like telephone reports from 1976 up until his death, and Hackett published them in 1989 as *The Andy Warhol Diaries*. Things take a more philosophical turn in another work that is also based on tape recordings: *The Philosophy of Andy Warhol (From A to B and Back Again)* appeared in 1975 and brought Warhol great success as an author. Warhol's look back at New York in the 1960s was published as *POPism: The Warhol Sixties* in 1980. He himself put together *Andy Warhol's Party Book*, while a photographic retrospective of his party days was published posthumously.

Another member of the Factory takes center stage in *a: A Novel* from 1968—"a" stands for amphetamine: the novel is about drugs. Its protagonist, Ondine (Robert Olivo), was in the habit of staying awake for twenty-four hours after taking drugs, and of talking incessantly. His ramblings were recorded over a longer period of time, certainly, but individual monologues do occasion-

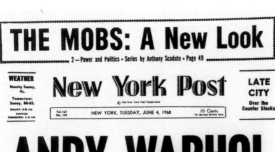

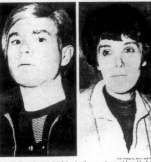

THE MOBS: A New Look

2—Power and Politics · Series by Anthony Scaduto · Page 49

New York Post

NEW YORK, TUESDAY, JUNE 4, 1968 10 Cents

LATE CITY

ANDY WARHOL FIGHTS FOR LIFE

Marcus Taking Stand

The front page of the *New York Post*, 4 June 1968: "Andy Warhol Fights For Life." A photograph of his assailant, Valerie Solanas, is also shown.

ally drag on for a matter of hours. The book's editor deemed it too chaotic and flawed, whereupon Warhol declared the whole thing to be a veritable masterpiece. Discussion over.

The Shooting

On 3 June 1968, the world of the Factory appeared to be at an end. The radical feminist Valerie Solanas, who had had a bit part in one of Warhol's numerous films, entered the Factory on Union Square and fired at Warhol and a journalist who was also present in the room. Critically injured, Warhol was rushed to hospital. Solanas turned herself in to the police, and explained that her feminist convictions lay behind her action. She wanted revenge on Warhol for demeaning women in his films. New York was shocked and media interest intense. The

New York Post published photographs of the victim and the perpetrator on its front page: "Andy Warhol Fights For Life" ran the headline. In her confused state of mind, Solanas was initially hospitalized. Her activities had been limited to a group that she founded (she was also its only member): S.C.U.M., the "Society for Cutting Up Men." In adverts placed in the underground press, Solanas advocated the complete elimination of the male sex. After her attack on Warhol, Solanas received the support of the National Organization of Women. While she had had no previous contact with it, it now recognized an ally in her. A few weeks after the attack, Solanas was charged with attempted murder, bodily harm, and illegal possession of a firearm, but was then committed to a psychiatric unit. In December 1968 she was judged fit to stand trial and released. Over the phone, she threatened Warhol to drop charges. It was the following February before she received a prison sentence.

Warhol with Fred Hughes, Taylor Mead, and Patrick Tilden-Close filming in New York, December 1967.

The Shooting's Consequences

Before long, Andy Warhol was on the road to recovery. In early September, he felt well enough to visit the Factory, but for the rest of his life he had to wear a corset. As much as he disliked hospitals, he had to subject himself to another lengthy stay in one. Even years later, on returning home from a skiing vacation in Aspen, he noted in his diary in early 1982 that his lungs were not quite in order: "My lungs are still funny from being shot, I guess." More than anything else, however, he was haunted by the fear that Valerie Solanas could again try to kill him. Andy Warhol was a different man after his attempted assassination in 1968. Even before it, he was barely able to curb his urge to buy things. His apartment increasingly came to resemble an Aladdin's cave. Spending

hours wandering around New York's flea markets, he now compulsively collected everything that he came across. Expensive items of furniture and cheap knick-knacks, as well as pictures by fellow artists like Robert Rauschenberg and Cy Twombly, found their way into his collection.

His studio changed, too. After the attack, Warhol and his entourage moved into new premises located only a few blocks away from the (second) Factory. Warhol had security cameras installed at this new studio; workers and visitors no longer came and went all the time. He no longer wanted some of the "kids" from his early Factory days around him: Ondine and Taylor Mead disappeared, as did the photographer Billy Name, and even Gerard Malanga, who had worked for Warhol since 1963.

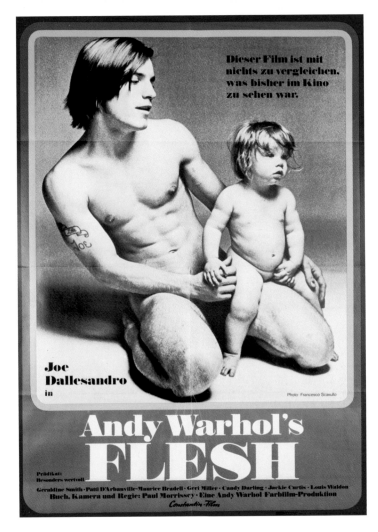

A poster (featuring Joe Dallessandro) advertising Warhol's film *Flesh* in 1968.

Artistically, Warhol again focused more on painting and silkscreen printing, but now let his assistants do more and more of the work. He discovered the new medium of video and began to record life in the Factory again.

A New Face

Over the next few years, Frederick W. Hughes became one of Warhol's closest associates. Fred, as he was known in the Factory, came from a good family, and knew how to make use of his network of society contacts, among whom the de Menil family of Texas played a crucial role. They particularly liked to invest their oil money in the artwork coming out of Warhol's workshop. Under Hughes, the Factory quickly became a successful business. In the winter of 1983/84, the Factory workers moved into a new base on Madison Avenue at 33rd Street. According to Warhol, the former electricity substation in midtown Manhattan not only had a great location: "The best thing about the building is the roof terrace. It could belong to an elegant, beautiful apartment."

While Fred Hughes dealt with the business side of things, Paul Morrissey took charge of film production. Warhol had glorified drugs in earlier films, but those days were now over. It was Morrissey above all who sounded a critical note. "Paul was tired of drugs being glamorized, he told me—especially in the movies. He wanted to completely take the romanticism away from

drug-taking—shoot a movie about a Lower East Side junkie and just call it *Trash*. It sounded like a good idea to me and I said sure, to go ahead." By and large, Warhol gave his collaborator free rein; after the shooting, he mostly kept out of film production.

Interview

Warhol invested much time in his *Interview* magazine. He started it in 1969, mainly, as he recalled, so that his assistant Gerard Malanga and the other Factory workers had something to do! To begin with, the monthly editions were largely about contemporary film; its first editors—Bob Colacello and Glenn O'Brien—were film students. O'Brien was matter-of-fact about the reason he was hired: "Bob and I were hired ... probably because our most important qualification was we didn't seem to be on amphetamines." Covering a wide range of topics and full of society gossip, *Interview* gradually developed into a magazine for the in-crowd.

Warhol invited New York's glitterati to pose for the front cover, recorded conversations on countless tapes, and barely let his Polaroid camera out of his hand. Stars and would-be stars were shown up—often mercilessly, warts and all. There was no lack of opportunities: in the late 1970s, Warhol's crowd was practically part of the furniture at Broadway's disco Studio 54. Among the club's regulars—frequently cocaine addicts—there was always someone willing to provide Warhol with material in a compromising interview.

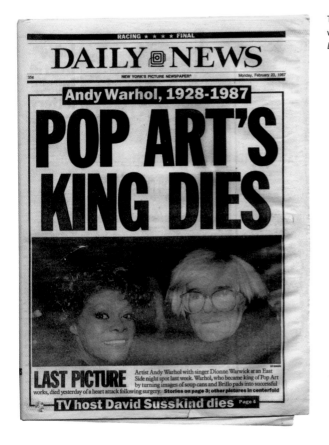

The death of Andy Warhol
was headline news in the
Daily News of 23 February 1987.

Sudden Death

Warhol was increasingly afflicted by physical ailments, which he confided above all to his telephone diary. They were not intended for the outside world; after all, he had fantasies that were far from human: "I want to be a machine." Despite gallbladder problems, Warhol traveled to Milan at the beginning of February 1987. He felt so ill he was barely able to enjoy the exhibition of his works based on Leonardo da Vinci's *Last Supper*. On returning to New York, he finally let himself be persuaded that a gallbladder operation was essential, and on 20 February he was admitted to New York Hospital. The operation the next day went well, but complications developed through the following night. Andy Warhol died on the morning of 22 February 1987. According to the post-mortem examination, he had had a heart attack or lung failure in his sleep. He was buried next to his mother's grave in his hometown of Pittsburgh, with only his immediate family in attendance. On 1 April, more than 2,000 mourners took their leave of Andy Warhol at a Mass held in New York's St Patrick's Cathedral.

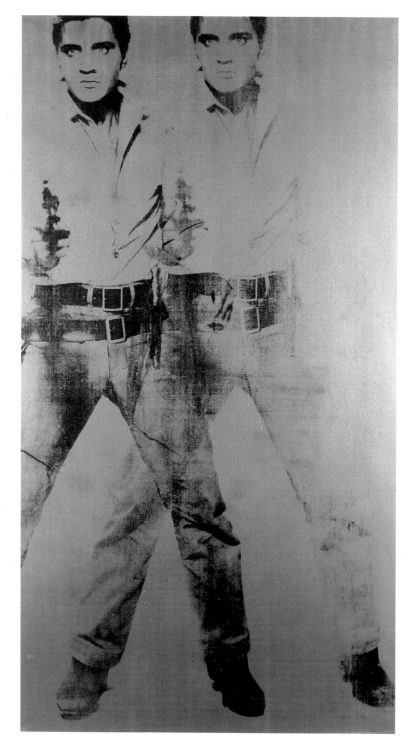

The King The King of Rock 'n' Roll also figured in Warhol's series of stars and starlets, of course. Warhol was fascinated by Presley's lasting success as a singer and actor. For the silver background in this *Double Elvis* from 1963, Warhol used a can of spray paint.

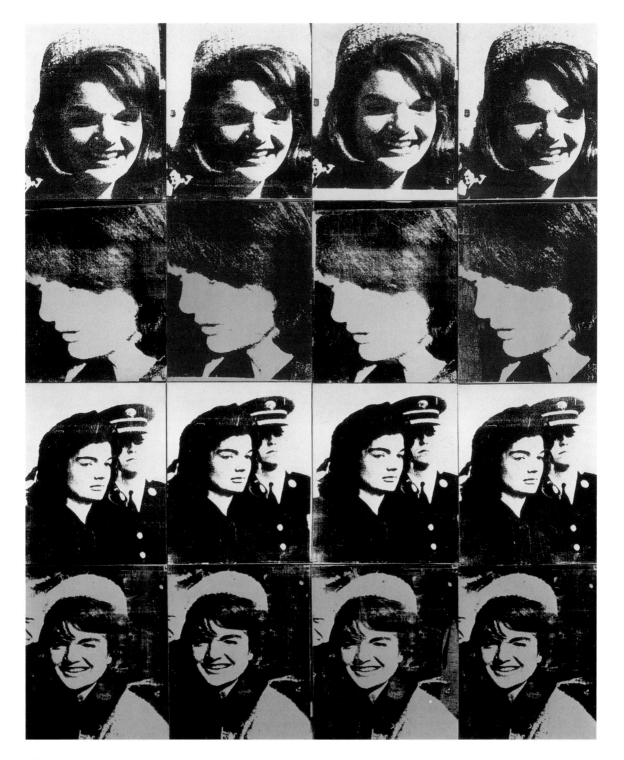

Jackie When US President John F. Kennedy was assassinated in 1963, Jacqueline Kennedy was sitting next to him. The events of November 1963 reverberated in the media for weeks. Andy Warhol combined different photos of the First Lady in *Sixteen Jackies*. He shows both the fashion icon sporting a pillbox hat, and the mourning widow.

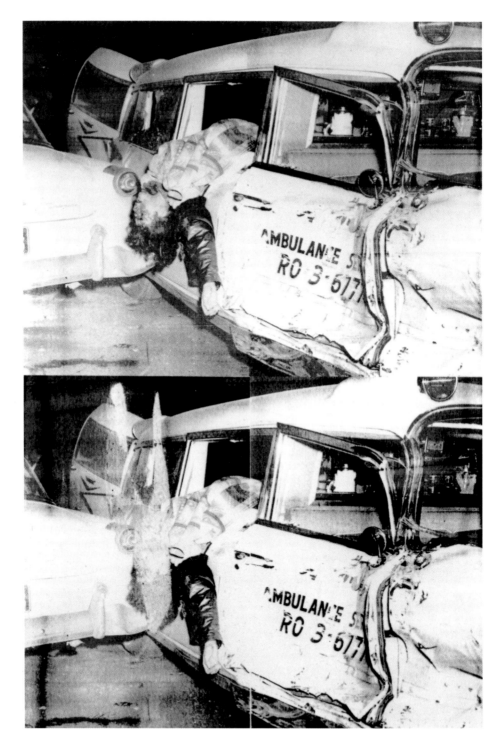

Ambulance Disaster High output at the Factory produced high numbers of works which in turn were intended to ensure high sales—even of works with subjects that at first sight do not appear to be marketable, such as a series of photographs showing an ambulance that had crashed. A silkscreen print from 1963.

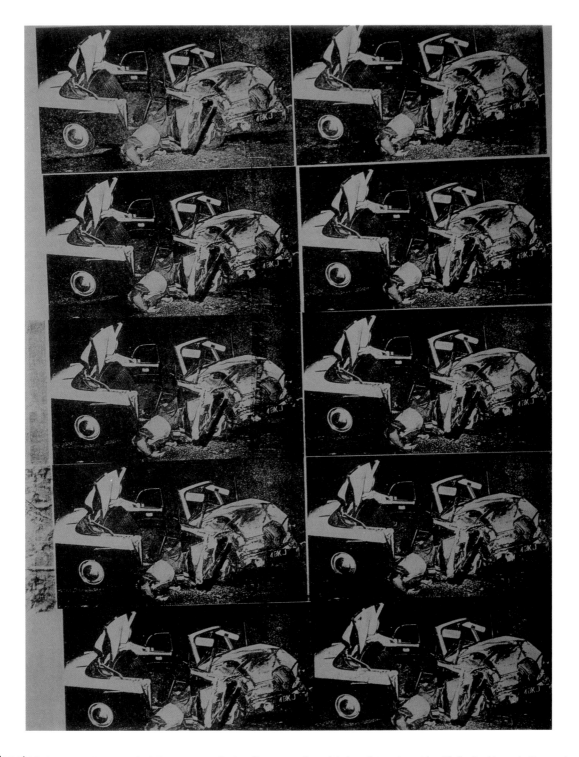

Disaster Warhol quickly recognized that even negative headlines roused people's keen interest—not least in buying his work. Time and again he worked on series of paintings with electric chairs or serial killers, skulls or accidents, such as here in *Green Car Crash (Ten Times)* from 1963.

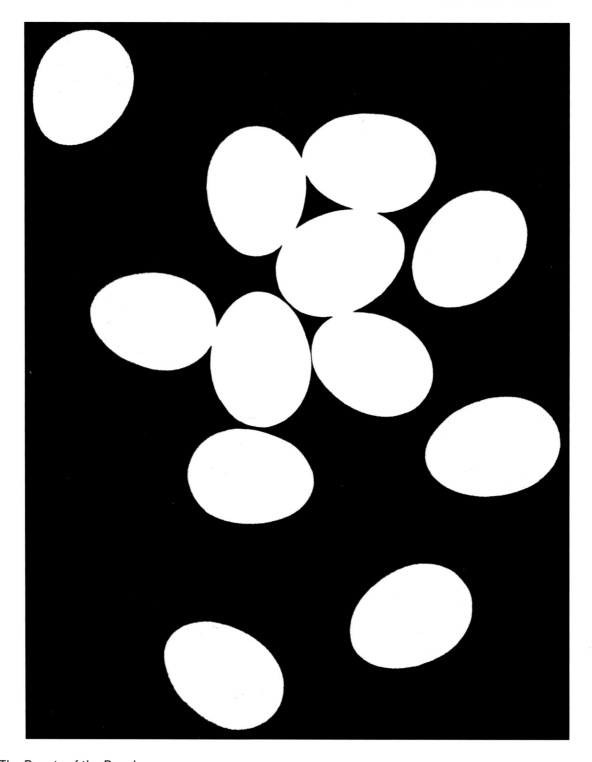

The Beauty of the Banal "... his artistic program was something like 'everything is fine.' Art makes even the most banal thing attractive." In a letter he wrote in 1991, this is how the German publisher Siegfried Unseld described the philosophy of Pop artist Andy Warhol. His comment clearly applies to Warhol's *Egg* paintings.

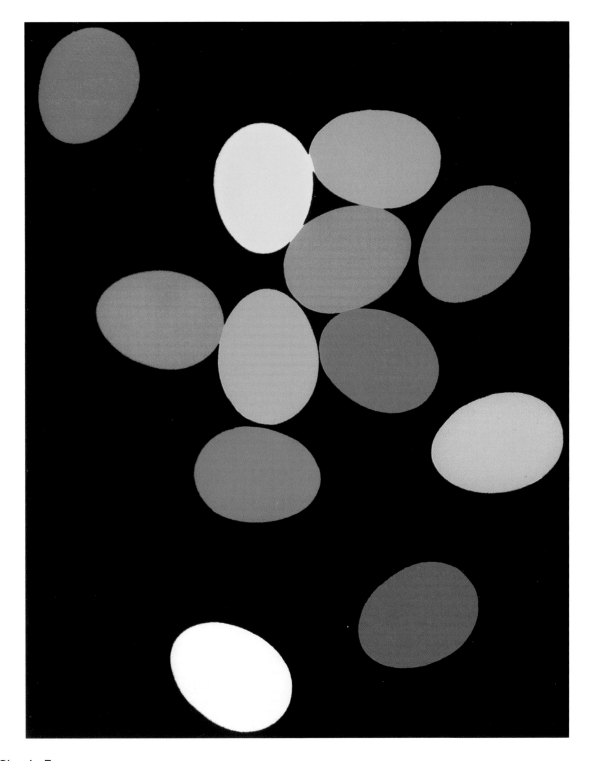

Simple Forms At 229 x 178 cm (7.5 x 6 feet), Warhol's painting of a dozen brightly colored eggs on a black background is not small. In 1982, Warhol produced a number of variations on the theme of Easter in a series of works that showed him moving away from Pop art towards Abstraction.

Yarn Warhol produced his *Yarn* series in 1983 as a commission for an Italian textile company. Critics have compared his technique with that of Jackson Pollock, though Warhol achieved the effect of Pollock's poured and dripped paint in his own way.

Abstract Warhol's *Yarn* images belong to his series of abstract works. Though taking objects as his starting point, he increasingly distanced himself from reproducing them in recognizable form. Even in his earlier *Shadows* series from 1978/79, the objects are barely identifiable.

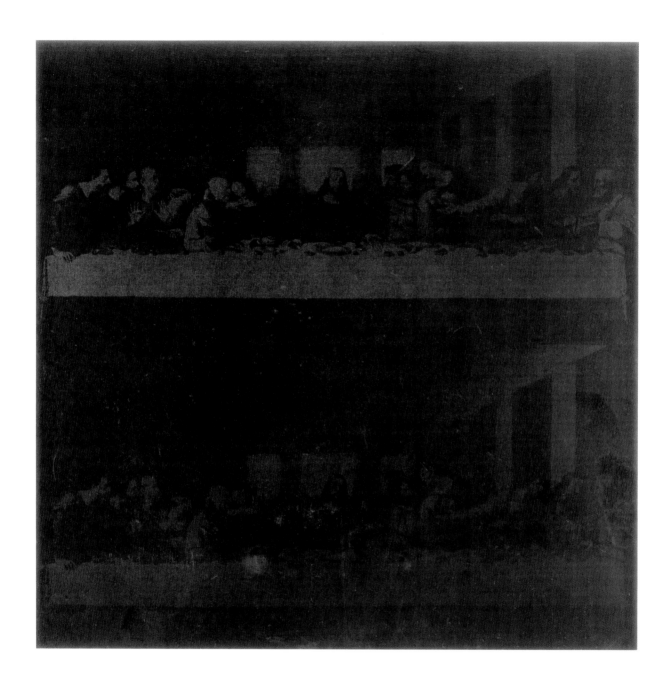

Another Icon Whether he had seen Leonardo da Vinci's monumental *Last Supper* or not, Warhol's own versions of the painting are in great demand. Following his death in 1987, one of his *Last Suppers* sold at auction for $1.7 million.

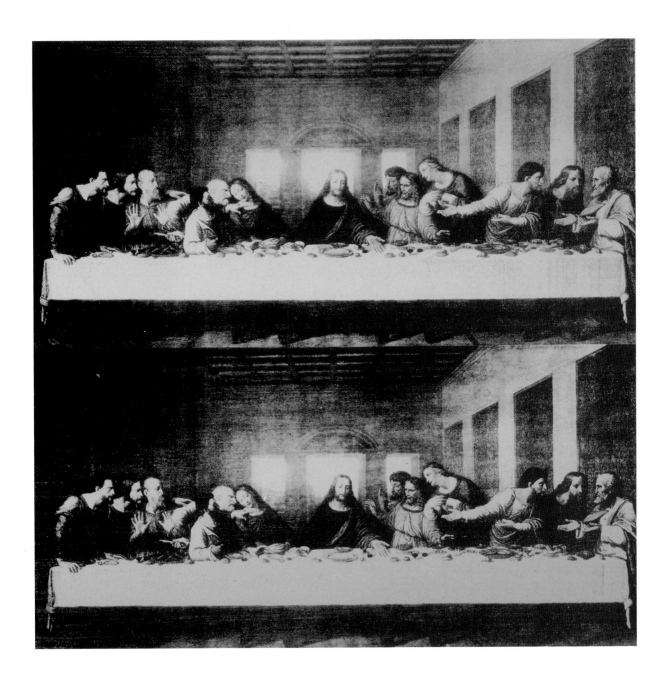

Irony Was Andy Warhol really so ignorant about Italian art as the artist Janis Kounellis suggested to Joseph Beuys in 1985? "Five years ago, this awful painter called Andy Warhol came to Italy. Sitting around a table with Moravia and others, someone asked the idiot which Italian artists he knew. He replied that the only Italian thing he knew was spaghetti ..."—"It was meant ironically."—"No, he was not being ironic in the least. He said something deeply insulting. He has no talent, he's a self-publicist; he is no artist."

Love

"Sex and parties
are the only
things you have
to show up for
in person."

Andy Warhol

Exciting Times

From mid-century onwards, American society underwent rapid change. It enjoyed strong economic growth in the very conservative 1950s; alternative culture blossomed in the late 1960s and 1970s; and the 1980s was a time of infatuation with youth culture—and an era marked by deep fear of something new: AIDS. Warhol and his crowd were in the thick of it.

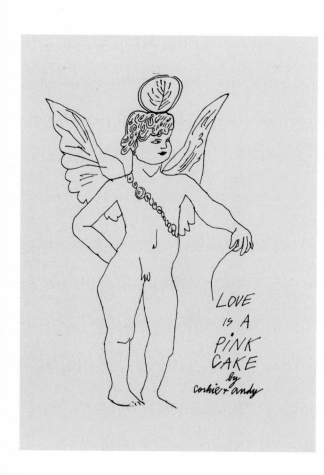

Title page of *Love is a Pink Cake*, 1953, by Corkie (Ralph T. Ward) and Andy Warhol.

Love is a Pink Cake

Warhol's first treatment of other people's sexual relationships was light-hearted. In 1953 he illustrated humorous poems by Ralph T. Ward in a book called *Love is a Pink Cake* (they undertook several projects that year). Ward satirizes famous couples such as Samson and Delilah, Chopin and George Sand. Warhol's drawings reflect Ward's sense of irony.

AIDS ...

→ ... was first officially recorded as a disease in June 1981, and

→ ... was initially associated solely with gay men.

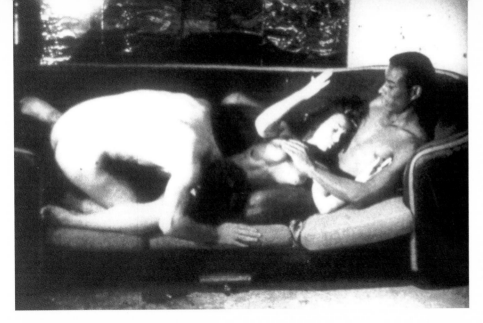

Beat Generation

1950s America was far from being a progressive country: narrow-minded middle-class values and social norms prevailed. To counteract them, members of the so-called Beat Generation espoused an alternative life style. They defined underground culture in the years following World War II, and were mostly devotees of the European literary avant-garde. Besides their interest in literature, what united them was their rejection of convention and their desire to expand their consciousness through the use of drink and drugs. Their work juxtaposes accounts of their experiences with drugs, profanities, and political statements—often quite incoherently. Jack Kerouac and Allen Ginsberg, two of the earliest Beat poets, were visitors to the Factory. Both of them play roles in Warhol's film *Couch,* in which they engage in sex upon a sofa.

"It is an amusing contradiction that Andy, who so loved gossip and celebrity culture, timidly shielded his own private life and the private meaning of his work from public scrutiny."

Henry Geldzahler

Peep Show

On recovering from the injuries he sustained in the shooting, Warhol's first walk was to a peep show. The artist never made a secret of the fact that he enjoyed pornography, and in his own films he was often determined to test the boundaries of permissiveness. With *Blue Movie* in 1968 he went too far: New York authorities deemed the film pornographic and banned it. Warhol viewed that as harassment.

As freely as he treated eroticism and pornography over
many years in his paintings, films, and photographs, Warhol
remained tight-lipped about his own love life.

Togetherness in the book *In the Bottom of My Garden*, illustrated by Warhol in 1955.

A Very Private Superstar

"Introverted" and "shy" are two words that are often used by his friends to describe Andy Warhol. Beyond his colorful circle at the Factory, it is true that little is known about his private life. While there are many photos of him and his assistants, photos of Warhol's partners are scarce.

Observer in the Background

While the Factory Kids, as Warhol called them, went on at great length behind and in front of the camera about every aspect of their love lives, Andy stayed in the background. Observing and recording events with his tape recorder and Polaroid camera, he again took the role of voyeur in his 1964 silent film *Couch*. The leading role went to a large studio sofa upon which Factory workers and visitors engaged in a whole range of sexual practices (page 93). And Warhol? As ever, he remained behind the camera.

> "If you want to know all about Andy Warhol, just look at the surface of my paintings and films and me, and there I am. There's nothing behind it."
>
> **Andy Warhol**

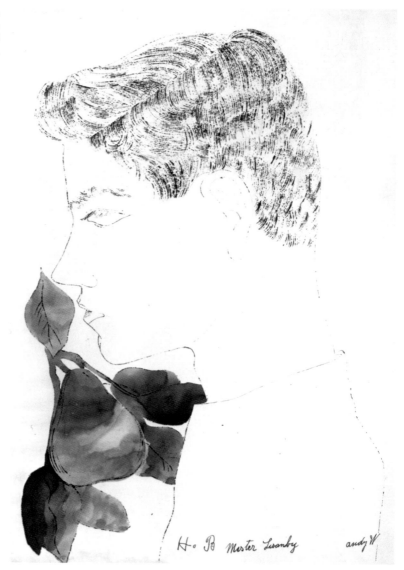

Behind the Scenes

Warhol's contemporaries in the alter-
native art scene in 1950s New York also
describe him as a silent observer.
Warhol, it appears, preferred to reach
for pen and paper when he wanted to
express himself. He made pen studies
of his then partner, the set designer
Charles Lisanby (above), around this
time. He showed them at New York's Bodley Gallery, but
his *Drawings for a Boy-Book* received a muted re-
sponse, and the planned book did not materialize. Andy
had other plans, anyway: in the summer of 1956, he and
Lisanby left for Asia and Europe. From Japan, by way of
a number of intermediate stops, they traveled to India.
Their first stop in Europe was Rome, followed by
Amsterdam, Paris, London, and Dublin. Numerous
souvenirs from this trip were found among the
objects Warhol collected.

Truman Capote: Warhol's Idol

Warhol never denied being gay, but neither did he make
an issue of it. Unlike his contemporary Truman Capote,
who caused a sensation in 1948 when, aged twenty-
three, he published his first novel, *Other Voices, Other
Rooms*. At the same time, Capote knew how to put him-
self in the limelight: his affairs with men were as much
the talk of the town as his successes as a writer. Warhol
was not unmoved by this dandy, either, and produced
drawings to illustrate his work. He sent them to him, but

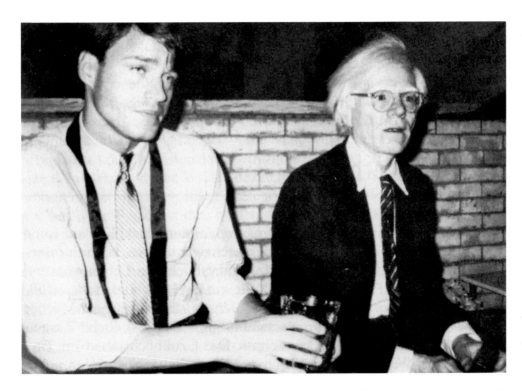

Andy Warhol and his long-term partner, Jed Johnson, shortly before they separated in 1980.

that was not enough: "I wanted to illustrate his stories so badly, I used to pester him with phone calls all the time—till one day his mother told me to cut it out."

Partner and Collaborator

In the 1960s, Warhol started a long-term relationship with office boy Jed Johnson, who had delivered telegrams to the Factory. Dissatisfied throughout his life with his own appearance, Warhol was greatly taken with Johnson's good looks, and hired him in 1967. Especially after the shooting by Valerie Solanas, Jed was a great support to him. Warhol now shielded his private life even more rigorously than before. Superstar Viva, who played in many of his films, recalls: "After the shooting Andy was really scared of women ... he was scared of them sexually even before it. I mean you couldn't touch him without him wincing. Maybe he was just play-acting with that, but afterwards he seemed really scared." After Warhol was discharged from hospital, Johnson moved in with him. He looked after Warhol and liaised between him and the Factory, which had in the mean-

time been managed by Paul Morrissey. Warhol now moved into his New York townhouse that he and Jed shared for over ten years. Their relationship broke down at the end of 1980. Warhol did not give much away; only rarely does he describe life together with Jed in his diaries. Just before they split up in December, Warhol did at least write this: "And life gets more exciting every day, but then I had to go home to my horrible home life where the situation with Jed is getting worse every day." A few days before Christmas, Jed moved out. His name is rarely mentioned after that.

A New Lease of Life

As before, Warhol did not miss a party, but his health was deteriorating. On splitting from Jed, he began to take more painkillers and sedatives. At the same time, he became obsessed with his health: he took vitamins and became a fitness fanatic; he even listened to some faith healers. Cosmetic surgery (again) became an option. If at parties Warhol met people who had had a face-lift, he would interview them about it. Despite his dread

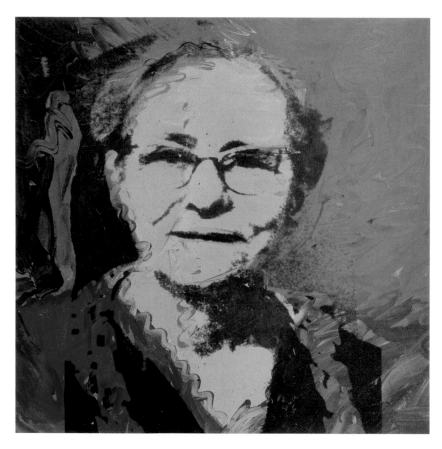

Andy's mother—and
long-time collaborator
and roommate
—Julia Warhola, in 1974.

of hospitals, he had undergone his first "nose job" in 1957. His concern about his looks was heightened when he met a new love: Jon Gould was not only thirty years younger than Warhol, he even worked at the Paramount film studio in Los Angeles, where he mixed with California's glitterati. Gould moved into Warhol's New York townhouse in 1984, but they did not live together for long. That same year it was discovered that Gould was infected with HIV. Only months later, he left the house. Thereafter he ceased to exist for Warhol, whose diaries reveal his fear of becoming infected himself. Around this time, ideas about how AIDS develops and is passed on

were still very vague. Gould finally died in 1986, a year before Andy Warhol.

Secretive to the Last

Warhol handled illness and death with characteristic cynicism. In works like *Suicide (Fallen Body)* from 1963 or his *Electric Chair* series, he approached the subject without fuss. Privately, he tended to close his mind to it. When one of his closest friends, his former superstar Edie Sedgwick, died in 1971, Warhol barely showed any emotion. Even the death of his long-time *Interview* editor, as well as the death in 1984 of his idol Truman

Andy Warhol and his shadow: the subject of a series of self-portraits in 1981.

Capote, did not touch him. "I try to avoid funerals, but if you don't go to them, you soon forget who's gone to heaven. Friends die, and after three months I ask people how they're doing."

When in 1972 his mother Julia died (they had shared the same home and worked together for years) he again treated the subject of death artistically. At the same time, he kept his mother's death a secret. Even years later, according to his associates, when he was asked how she was, he would answer without mentioning that she had died.

A Gold Book In his studies and portraits for his *A Gold Book*, Warhol uses delicate, broken lines to reproduce the contours of his subjects. His treatment of these works, which are based on photos, is far freer than in his later portraits. The bound book, of which one hundred copies were produced, contains eighteen prints.

Early Work Warhol published a luxury edition of his latest work when he was almost thirty. His drawings for *A Gold Book* were printed on gold paper in 1957. He'd been a successful commercial illustrator for almost ten years by now, yet the response to these drawings was limited. Warhol was still at the beginning of his career as a freelance artist.

Do It Yourself is the instruction here. Warhol and his associates partly painted this series of pictures themselves, but it was up to the buyer to do most of the work. These do-it-yourself paintings sold well, in fact. The idea worked: painting by numbers appealed to public taste of the day.

Painting by Numbers Warhol's *Do It Yourself* pictures are shown at various stages of completion. This large-canvas view of this house and boats by the sea has already been completed in acrylic; the numbers identifying the color of paint to be used are still visible.

New Direction On being asked in 1976 by his assistant Glenn O'Brien why he had not been painting much, Andy Warhol replied, "… nothing comes to mind. I don't want to paint any more. I've been trying for a long time to give up painting … It is so boring always painting the same thing."

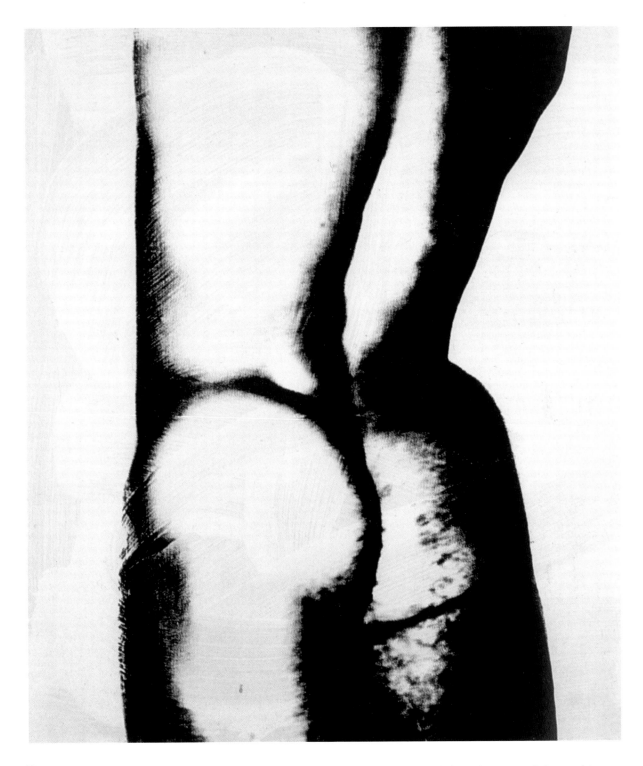

Torso The *Torsos* series was produced despite Warhol's protestation that he wanted to give up painting and concentrate in future solely on producing films. Perhaps the motifs on offer at the Factory were simply too attractive...

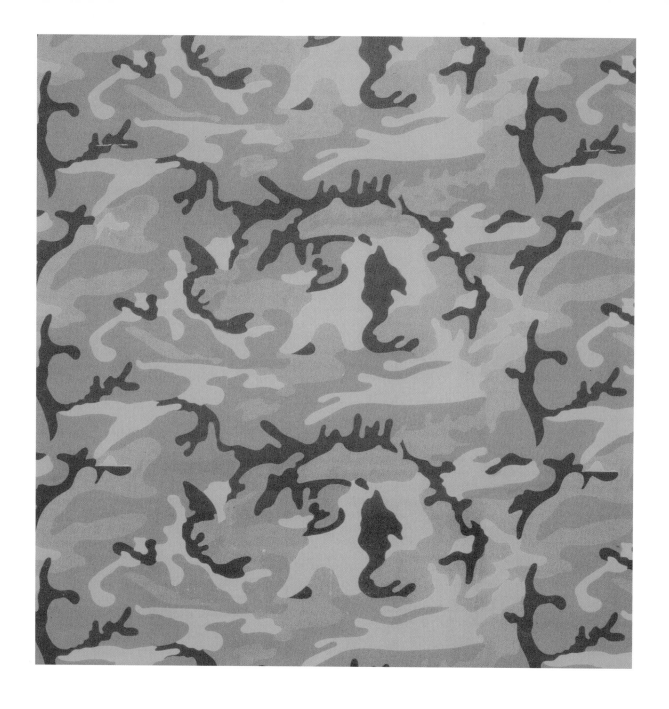

Camouflage In 1986, Warhol began to use camouflage, even in self-portraits. At about 3 x 10 meters (9.5 x 33 feet), the camouflage painting illustrated here (without a self-portrait) was a monumental piece of work among this series of paintings, which also employed other, brighter colors than those shown here.

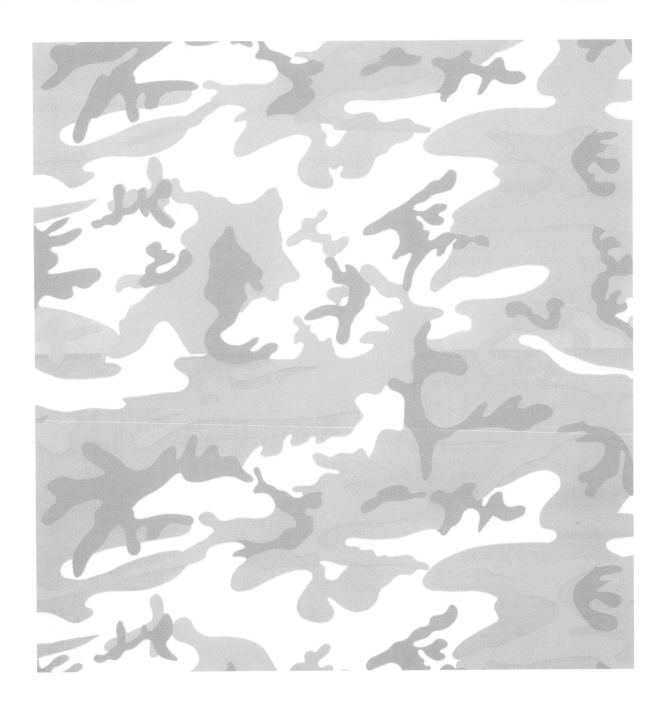

Compliment After the opening of an exhibition of his abstract *Shadows*, Warhol was persuaded to stroll around the galleries close by: "It's always great to see art that's better than mine on the other side of the street," was the artist's opinion later.

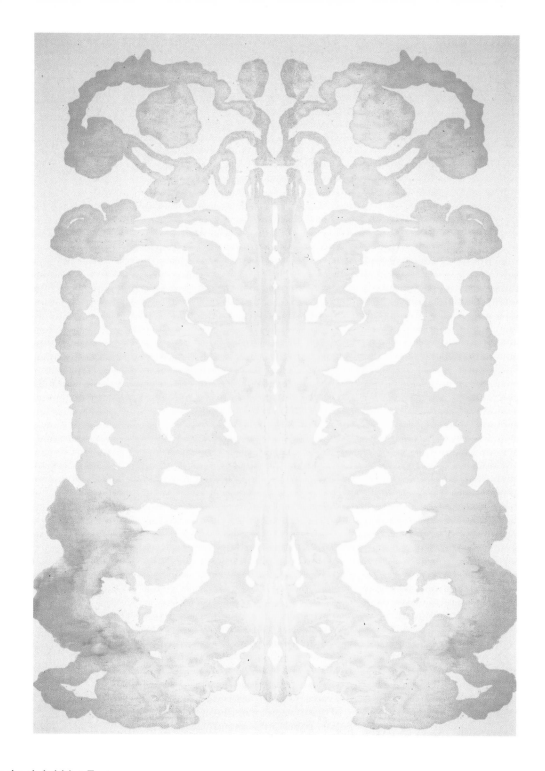

Rorschach Inkblot Test Hermann Rorschach had initially wanted to become an artist, but finally chose to study medicine. According to Rorschach, whatever people spontaneously associated with these images revealed aspects of their character.

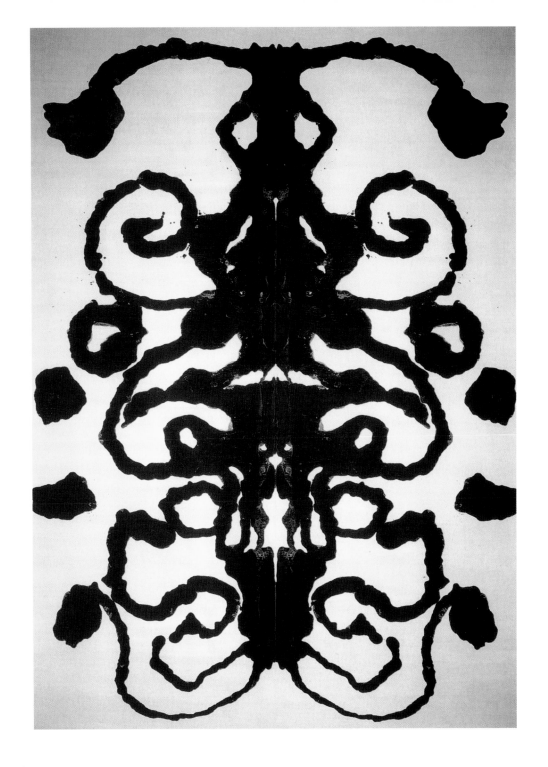

Decorative Warhol produced several variations on the Rorschach theme in 1984. Painted in acrylic on canvas, they are all monumental in size. This black-and-white painting measures roughly 4 x 2.8 meters (13 x 9 feet). We can only guess what Warhol associated with this image.

Warhol Today

"Warhol is significant for showing with the means of repetition that in art there is no repetition."

John Cage on Andy Warhol (seen here together with Jean-Michel Basquiat)

Vast Legacy

Even now, Andy Warhol's estate has still to be cataloged in full. Not only his creativity knew no bounds; even as a collector he was insatiable. This is best appreciated on a visit to the Andy Warhol Museum in his hometown of Pittsburgh.

Still Awaiting Discovery

Known also as his *Time Capsules*, the 612 cardboard boxes that Warhol left behind are a good illustration of his approach. Starting in the early 1970s, he began to collect simply *everything*—old bills, envelopes, pages from newspapers, postcards, instant photos. The list goes on. These "biographical boxes" offer lots of valuable clues to him and his work. In *The Philosophy of Andy Warhol (From A to B and Back Again)*, the artist does not shy away from giving advice to anyone wanting to create their own Time Capsule: "Get a box each month, throw everything in it, and tape it down at the end of the month. Put the date on and send it over to Jersey. Try and keep an eye on it, but if you can't and it gets lost, that's okay because that's one less thing you have to think about ..."

Auction prices ...

→ ... for Warhol's works often set records. In 1997, Christie's sold a quadruple Warhol self-portrait from 1978/79 for almost one million dollars, and

→ ... a year later, an *Orange Marilyn* from 1964 was worth almost $16 million to another buyer at Sotheby's!

Andy Warhol Museum

Opened in 1994, the Andy Warhol Museum gives an insight into four decades of intense artistic creativity. Visitors can marvel at more than 8,000 of the artist's works across all genres: painting, drawing, silkscreen, film, photography, sculpture, and installation. Items from his private collection, such as his many cookie jars (right), are also on display. For anyone still missing a piece of Pop Art at home, the museum shop can provide banana-shaped bowls or a "Marilyn" mouse pad.

Drella

Warhol had a hand in the success of the band *The Velvet Underground*, who appeared in his happenings. In 1990, its founding members, Lou Reed and John Cale, paid homage to Warhol on an album, *Songs for Drella*. A conflation of Dracula and Cinderella, "Drella" was Warhol's nickname. Working with him was probably not always sheer unalloyed joy...

"Andy Warhol was the perfect mirror of his time, and without doubt the artist we deserved."

Carl André

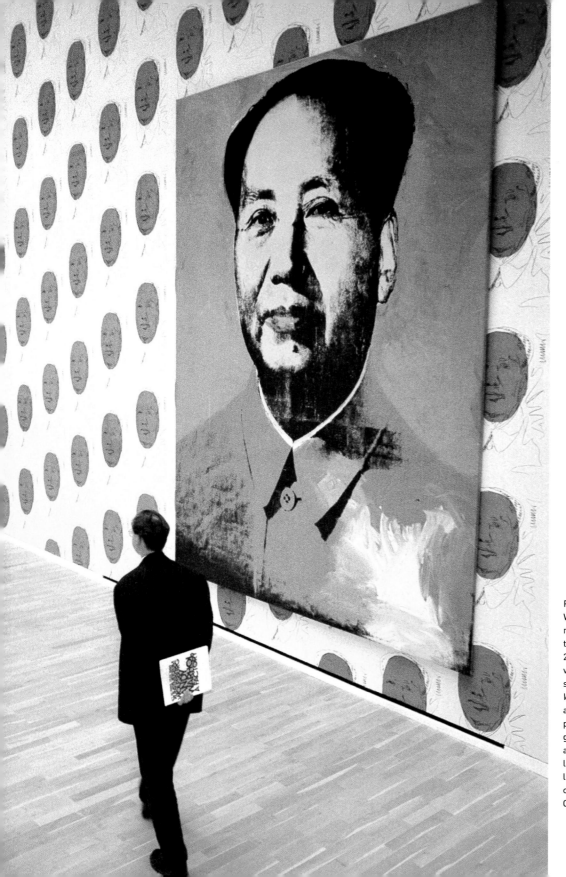

Probably every area of Warhol's work has by now received the attention it deserves. In 2004, almost 75,000 visitors turned up to see the exhibition *Andy Warhol. The Late Work* at Düsseldorf's kunst palast, where photographs, videos, films, and paintings from the last fifteen years of his life were on show, including this portrait of Chairman Mao.

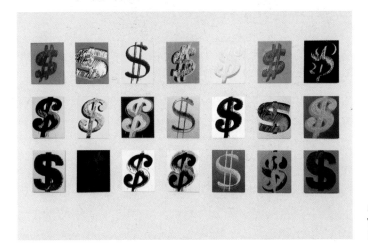

In 1982, Leo Castelli exhibited Warhol's *Dollar Signs* in his New York gallery.

No End to Andy Warhol

It was a smart move by Andy Warhol to make use of the techniques of mass production for the purposes of art as they allowed free interchange between the boundaries of art and commerce. It became almost impossible to avoid his motifs, and he remains a major influence to this day.

Death of a Collector

When Andy Warhol died in 1987, *New York Magazine* estimated his fortune at over $100 million. His spacious townhouse contained a huge collection of works of art old and new, precious items of furniture, huge quantities of worthless knick-knacks, kitschy souvenirs from his trips, valuable porcelain, jewelry and watches, Native American art ... Even unopened shopping bags were still among his possessions. Staff from Sotheby's needed months to catalog all of Warhol's belongings, and it took over two weeks to auction them off. Proceeds from the sale of the inventory of his home alone are said to have raised more than $25 million. Warhol's private art collection contained work he had bought or had ex-

> "At the end of my days, when I die, I want no trace of me to remain. And I want to leave nothing behind ... I want my machinery to vanish."
>
> **Andy Warhol**

SOTHEBY'S
FOUNDED 1744

Collectibles, Jewelry, Furniture,
Decorations and Paintings
NEW YORK
SUNDAY THROUGH TUESDAY, APRIL 24-26, 1988

The
Andy Warhol
Collection

Cover of the (six volume) catalog
for the auction of The Andy Warhol
Collection by Sotheby's
in New York, 1988.

changed with fellow artists. It, too, was sold off and raised yet more millions. His magazine *Interview* changed hands for the handsome sum of $12 million.

Endowment

Warhol had thought about how his immense wealth could be used. Besides providing for his family in his will, he also endowed a foundation: the Andy Warhol Foundation for Visual Arts has now supported innovative artistic projects since 1987. Warhol appointed Fred Hughes, his long-time collaborator, manager, and friend, as his executor.

No End to Success

The art market reacted immediately to Warhol's death: prices for his works rose to all-time highs. Ivan Karp, director of New York's Leo Castelli Gallery, and a friend of the artist, saw no gain in the development: "After Andy Warhol's death, the tabloid press systematically cashed in on his life, and his achievements as an artist were grossly distorted by the public and private trade in his paintings and prints. In fact, the inflated prices that were charged, and paid, for some of his less important works have led to a distortion of the whole art market ..." In 1989, New York's Museum of Modern Art staged a major Warhol retrospective that was later shown in Chicago, London, Cologne, Venice, and Paris. Indeed, the number of Warhol exhibitions seems to keep rising rather than falling. His Pop art continues to draw big crowds to museums and galleries across the world.

Sotheby's staff
spent months cataloging
Warhol's possessions.
Shown here is a view
of his kitchen.

Legacy as an Artist

Andy Warhol has also left behind an important legacy as an artist. His influence on our culture—and above all its artists—even extends beyond the 1990s. Jeff Koons, for instance, who was born in 1955, was just starting to show his work when Warhol died. Koons, too, is fascinated by the surface of things, and he has experimented with images from advertising and the nursery room. Warhol would certainly have enjoyed them.

Movie Star

Andy Warhol even lives on on the big screen. In 1996, director Julian Schnabel made a film about the graffiti artist Jean-Michel Basquiat. In *Basquiat*, a less camera-shy David Bowie does the honors as Andy Warhol, with Jeffrey Wright giving a convincing performance as the central character. In 2001, director Stanislaw Mucha made a film, *Absolut Warhola*, about the artist's Slovak roots. It was an amusing documentary about the late fame enjoyed by the small village of Miková, the Warhola family's original home.

Teamwork Jean-Michel Basquiat and Andy Warhol, *Untitled*, 1984. Basquiat's works are now among the most sought-after 20th-century art, and regularly set new records at auction. In terms of motifs, he is hardly any less eclectic than Warhol: graffiti and comic drawings, African masks, totems, animals, and various characters are found in his work. The paintings on which both artists collaborated were at first not especially popular, however.

Rabbit Whether *Michael Jackson and Bubbles* in porcelain, or shiny metallic rabbits modeled on items for sale at Woolworth's, the work of Jeff Koons is always sure to provoke lively debate. As with Warhol, advertising and entertainment are rich sources of motifs for Koons.

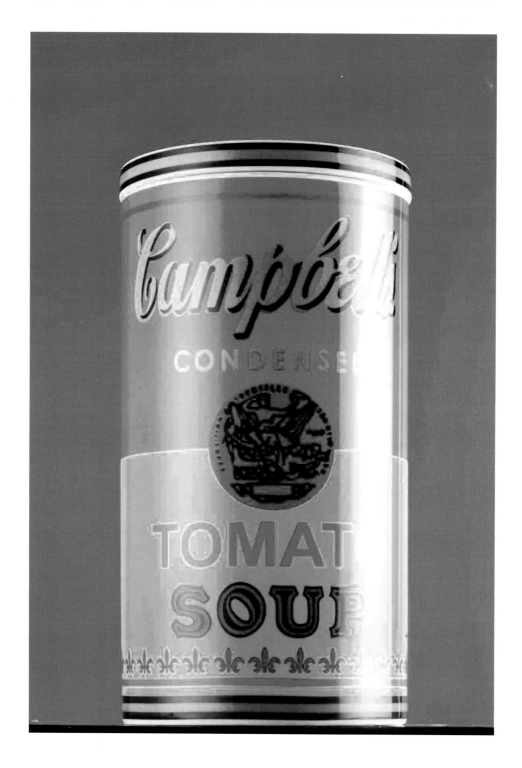

Ceramic Warhol During a visit to Germany in 1980, Warhol visited the Rosenthal Porcelain Factory in Selb to make a portrait of Philip Rosenthal. Rosenthal now markets its own Warhol collection that includes this *Campbell's Soup Can* vase.

Global Presence Warhol was everywhere in the 1980s: MTV gave him his own TV show, and his work was shown all over the world. Some designs for Diane von Fürstenberg's 2002 fall collection were inspired by the late artist.

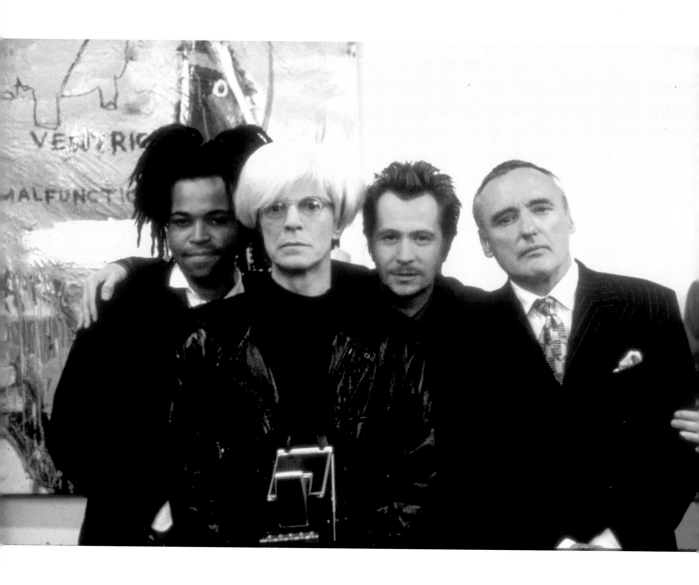

Basquiat Pop artists found a new lease of life on the big screen in 1996 when Julian Schnabel made a film about the graffiti artist Jean-Michel Basquiat, played by Jeffrey Wright. David Bowie played Andy Warhol, and Gary Oldman and Dennis Hopper also starred.

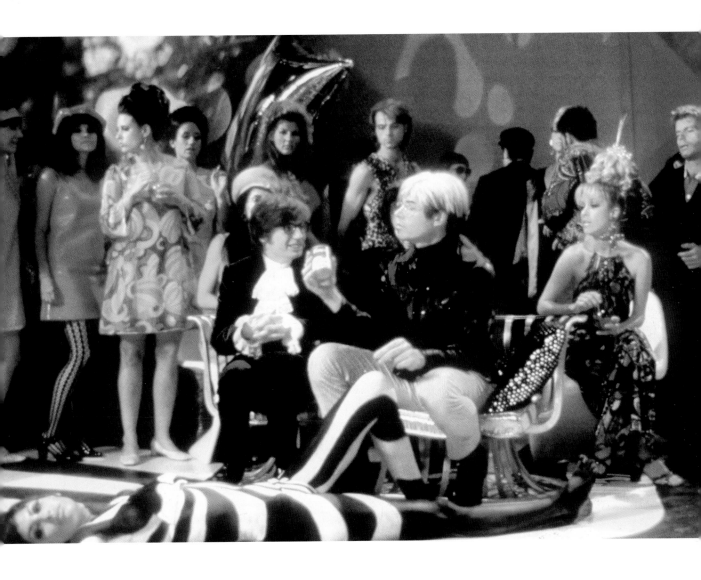

Film Star *Austin Powers: International Man of Mystery* (1997) was the first of three Austin Power comedies. Set first in the Swinging Sixties, the film could not do without an appearance by Andy Warhol, played by Mark Bringleson sporting a silver hairpiece.

Picture list

Context

P. 5: Statue of Liberty, New York City, photograph.
P. 6: Claes Oldenburg, *Soft Washstand (Ghost Version)*, 1965, linen, kapok, paint, wood, 135 cm, Ludwig Museum, Cologne.
P. 7 bottom: first album cover of the band *The Velvet Underground & Nico*, designed by Andy Warhol.
P. 8: Andy Warhol among Manhattan's skyscrapers, 1966, photograph by Herve Gloaguen.
P. 9: Greenwich Village in the 1950s, photograph.
P. 10: Allen Ginsberg, Gregory Corso and Barney Rosset on Washington Square 1957, photograph.
P. 11: Andy Warhol in his first Factory, a former hat factory in Manhattan, photograph by Ugo Mulas.
P. 12: Merce Cunningham and a member of his dance company performing *Rain Forest*, 1968, photograph.
P. 13: Tom Wesselmann, *Great American Nude # 98*, 1967, five canvases arranged in three rows, 250 x 380 x 130 cm, Museum Ludwig, Stiftung Ludwig, Cologne.
P. 14: Jackson Pollock, *No. 29*, 1950, oil and other materials on glass, 121 x 182 cm, National Gallery of Canada, Ottawa.
P. 15: Willem de Kooning, *Palisade*, 1957, oil on canvas, 201 x 175 cm, private collection.
P. 16: Andy Warhol, *Leo Castelli*, 1975, silkscreen on acrylic on canvas, 101.6 x 101.6 cm, Galerie Daniel Templon, Paris.
P. 17: Andy Warhol, *Jean-Michel Basquiat*, 1984, silkscreen on acrylic on canvas, 228.6 x 177.8 cm, Andy Warhol Foundation for the Visual Arts, Inc.

Fame

P. 19: Andy Warhol and friends, 1970, photograph.
P. 20: Andy Warhol and Joseph Beuys in Munich, 1980, photograph.
P. 21: Brigid Polk in *The Chelsea Girls*, 1966, film still.
P. 22: Andy Warhol, *Self-portrait*, 1964, silkscreen on acrylic on canvas, two panels, each measuring 50.8 x 40.6 cm, private collection.
P. 23: Andy Warhol, illustration for "Success is a Job in New York," *Glamour* magazine, 1949.
P. 24: Window installation for Bonwit Teller, New York, April 1961, photograph.
P. 25: *Brillo Boxes* at the Leo Castelli Gallery, 1964, photograph.
P. 26 left: Andy Warhol with fellow artists (left to right) Tom Wesselmann, Roy Lichtenstein, James Rosenquist, and Claes Oldenburg in New York, 1964, photograph.
P. 26 right: View of the *Andy Warhol* exhibition, Ileana Sonnabend Gallery, Paris 1965, photograph.
P. 27: View of the *Andy Warhol* retrospective at the Whitney Museum of American Art, New York 1971, photograph.
P. 28: Andy Warhol, *Dollar Bills, Front and Back*, 1962, silkscreen on canvas, two panels, each measuring 210.8 x 48.2 cm, Jed Johnson Collection.

P. 29: Andy Warhol, *Dollar Signs*, 1981, silkscreen on acrylic on canvas, 228.6 x 177.8 cm, private collection.
P. 30: Andy Warhol, *Flowers*, 1964, silkscreen on acrylic on canvas, 61 x 61 cm, José Mugrabi Collection and Isle of Man Co.
P. 31: Andy Warhol, *Flowers*, 1964, silkscreen on acrylic on canvas, 61 x 61 cm, José Mugrabi Collection.
P. 32: Andy Warhol, *Joseph Beuys*, 1980, silkscreen on acrylic on canvas, 101.6 x 101.6 cm, Anthony d'Offay Gallery, London.
P. 33: Andy Warhol, *Joseph Beuys*, 1980, silkscreen on acrylic on canvas, 101.6 x 101.6 cm, Anthony d'Offay Gallery, London.

Art

P. 35: Andy Warhol, *Brillo, Del Monte and Heinz Boxes*, 1964.
P. 36: Jasper Johns, *Painted Bronze (Ale Cans)*, 1960, painted bronze, Museum Ludwig, Cologne.
P. 37 top: Barnett Newman, *The Word II*, 1954, oil on canvas, 228 x 178 cm, Onnasch Collection, Berlin.
P. 37 bottom: Andy Warhol, *Giorgio Armani*, 1983, silkscreen on acrylic on canvas, 101.6 x 101.6 cm, José Mugrabi Collection.
P. 38: Andy Warhol, *Campbell's Tomato Soup Can*, 1968, silkscreen on acrylic on canvas, 38 x 25.4 cm, José Mugrabi Collection.
P. 39: Andy Warhol, advertisement for I. Miller in the *New York Times*, 1955/56.
P. 40: Andy Warhol, *Christmas Card*, 1953, offset print, 28 x 21.5 cm, Tilman Osterwold Collection, Stuttgart.
P. 41: Andy Warhol, *Superman*, 1960, silkscreen on acrylic and pastel on canvas, 170 x 133 cm, Gunter Sachs Collection.
P. 42: Andy Warhol, *Big Torn Campbell's Soup Can (Vegetable Beef)*, 1962, acrylic on canvas, 182 x 136 cm, Kunsthaus Zurich.
P. 43: Two views of the *Andy Warhol* exhibition, Leo Castelli Gallery, New York 1966, photograph.
P. 44: Warhol filming, 1969, photograph.
P. 45: Andy Warhol with Jane Holzer, 1969, photograph.
P. 46: Andy Warhol, *Hot Dog*, 1957/58, ink drawing and watercolor, 51 x 76 cm, Michael Becher Collection, Bremen.
P. 47: Andy Warhol, *Judy Garland*, 1956, collage, ink drawing and gold leaf, 51.2 x 30.4 cm, Michael Becher Collection, Bremen.
P. 48: Andy Warhol, *The Foxtrot*, 1962, acrylic on canvas, 182.9 x 137 cm, private collection.
P. 49: Andy Warhol, *Thirty Are Better Than One*, 1963, silkscreen on canvas, 279.4 x 240 cm, private collection.
P. 50: Andy Warhol, Robert Indiana in *Eat*, 1963, film still.
P. 51: Andy Warhol, *Empire*, 1964, film still.
P. 52: Andy Warhol, *Oxidation Painting*, 1978, mixed media on copper plate, paint on canvas, 193 x 132 cm, Andy Warhol Foundation for the Visual Arts, Inc.
P. 53: Andy Warhol, *Shadows*, 1978/79, silkscreen on acrylic on canvas, 198 x 127 cm, Andy Warhol Foundation for the Visual Arts, Inc.

P. 54: Andy Warhol, *Shadows*, 1978/79, silkscreen on acrylic on canvas, 193 x 132 cm, Andy Warhol Foundation for the Visual Arts, Inc.
P. 55: Andy Warhol, *Shadows*, 1978/79, silkscreen on acrylic on canvas, 193 x 132 cm, Andy Warhol Foundation for the Visual Arts, Inc.

Life
P. 57: Andy Warhol with Candy Darling, 1969, photograph.
P. 58: Andy Warhol with Jerry Hall and others in Studio 54, 1970s, photograph.
P. 59 top: Andy Warhol and the dog Archie accompanied by an unknown woman, photograph.
P. 59 bottom: Andy Warhol, *Apple*, 1983, silkscreen on acrylic on canvas, José Mugrabi Collection and Isle of Man Co.
P. 60: Andy Warhol, photograph by Nat Finkelstein.
P. 61: Andy Warhol, diary entries for December 1962, photograph, archives of the Andy Warhol Museum, Pittsburgh.
P. 62 left: Andrew Warhola with his mother Julia and brother John, around 1931, photograph.
P. 62 right: The Warhola Brothers: Paul, Andrew, and John in Pittsburgh around 1942, photograph.
P. 63: Andy Warhol 1945, photograph.
P. 64: Andy Warhol, *To Ernest the Andy Warhol Mother's Cake*, a page from the *Wild Raspberries* cookbook, 1959, handcolored offset print.
P. 65: Andy Warhol, "Baby" Jane Holzer in *13 Most Beautiful Women*, 1964, film still.
P. 66: Andy Warhol, *Self-portrait*, 1942, pencil on paper, 48.3 x 34 cm, private collection.
P. 67: Andy Warhol, *Self-portrait*, 1979, Polaroid photograph, 61 x 50.8 cm, Estate of Andy Warhol.
P. 68: Andy Warhol, *Popeye*, 1961, acrylic on canvas, 173 x 150 cm, Collection of Mr. and Mrs. S.I. Newhouse, Jr.
P. 69: Andy Warhol, *Nancy*, 1960, acrylic on canvas, 101.5 x 137.1 cm, Collection of Mr. and Mrs. S.I. Newhouse, Jr.
P. 70: Andy Warhol, *David Hockney*, 1974, silkscreen on acrylic on canvas, 101.6 x 101.6 cm, Shirley and Miles Fiterman Collection.
P. 71: Andy Warhol, *Roy Lichtenstein*, 1976, silkscreen on acrylic on canvas, 101.6 x 101.6 cm, Dorothy and Roy Lichtenstein Collection.
P. 72: Andy Warhol, *Marilyn Monroe (Twenty Times)*, 1962, silkscreen on acrylic on canvas, 195 x 113.5 cm, José Mugrabi Collection.
P. 73: Andy Warhol, *Four Marilyns (Reversal), Black on Bright Green*, 1979–1986, silkscreen on acrylic on canvas, 91.5 x 71 cm, José Mugrabi Collection.
P. 74 left: Book cover of *The Philosophy of Andy Warhol*.
P. 74 right: Book cover of *The Andy Warhol Diaries*.
P. 75: Front page of the *New York Post*, 4 June 1968.
P. 76: Andy Warhol with Fred Hughes, Taylor Mead, and Patrick Tilden-Close filming in New York, December 1967, photograph.

P. 77: German film poster for Andy Warhol's film *Flesh*, 1968.
P. 78: Cover of the first edition of Andy Warhol's *Interview* magazine, 1969.
P. 79: Front page of the *Daily News*, 23 February 1987.
P. 80: Andy Warhol, *Double Elvis*, 1963, silkscreen on acrylic on canvas, 211 x 115 cm, José Mugrabi Collection and Isle of Man Co.
P. 81: Andy Warhol, *Sixteen Jackies*, 1964, silkscreen on acrylic on canvas, 203.2 x 162.6 cm, Walker Art Center, Minneapolis.
P. 82: Andy Warhol, *Ambulance Disaster*, 1963, silkscreen on acrylic on canvas, 302.9 x 203.2 cm, Dia Art Foundation, New York.
P. 83: Andy Warhol, *Green Disaster (Ten Times)*, 1963, silkscreen on acrylic on canvas, 267.5 x 201 cm, Museum für Moderne Kunst, Frankfurt.
P. 84: Andy Warhol, *Egg Painting*, 1982, silkscreen on acrylic on canvas, 229 x 178 cm, Andy Warhol Foundation for the Visual Arts, Inc., New York.
P. 85: Andy Warhol, *Egg Painting*, 1982, silkscreen on acrylic on canvas, 229 x 178 cm, Andy Warhol Foundation for the Visual Arts, Inc., New York.
P. 86: Andy Warhol, *Yarn Painting*, 1983, silkscreen on acrylic on canvas, 102 x 102 cm, Andy Warhol Foundation for the Visual Arts, Inc., New York.
P. 87: Andy Warhol, *Yarn Painting*, 1983, silkscreen on acrylic on canvas, 102 x 102 cm, Andy Warhol Foundation for the Visual Arts, Inc., New York.
P. 88: Andy Warhol, *Last Supper, Black on Black*, 1986, silkscreen on acrylic on canvas, 99.5 x 99.5 cm, José Mugrabi Collection.
P. 89: Andy Warhol, *Last Supper, Black on Green*, 1986, silkscreen on acrylic on canvas, 99.5 x 99.5 cm, José Mugrabi Collection.

Love
P. 91: Andy Warhol with Viva, 1968, photograph.
P. 92: Title page of *Love is a Pink Cake*, 1953, Corkie (Ralph T. Ward) and Andy Warhol, printed on blue paper, 27.7 x 21.5 cm.
P. 93 top: Andy Warhol, *Couch*, 1964, film still.
P. 93 bottom: Andy Warhol, *Torsos*, 1977, silkscreen on acrylic on canvas, 127 x 508 cm, private collection.
P. 94: Andy Warhol, *Quarrel*, 1982, silkscreen on acrylic on canvas, private collection.
P. 95: Andy Warhol, drawing from *In the Bottom of My Garden*, 1955.
P. 96: Andy Warhol, *H.B. Mister Lisanby*, 1956, watercolor and ink drawing, 45.5 x 31.7 cm, Charles Lisanby Collection, New York.
P. 97: Jed Johnson and Andy Warhol 1980, photograph by Victor Bockris.
P. 98: Andy Warhol, *Julia Warhola*, 1974, silkscreen on acrylic on canvas, one of two panels, 101.6 x 101.6 cm, Andy Warhol

Foundation for Visual Arts, Inc.

P. 99: Andy Warhol, *Myths: The Shadow*, 1981, silkscreen on acrylic on canvas, 152.4 x 152.4 cm, Ronald Feldman Fine Arts, New York.

P. 100: Andy Warhol, page from *A Gold Book*, 1957, offset print on gold paper.

P. 101: Andy Warhol, page from *A Gold Book*, 1957, offset print on gold paper.

P. 102: Andy Warhol, *Do It Yourself (Violin)*, 1962, acrylic and transfer numbers on canvas, 137 x 182.9 cm, private collection.

P. 103: Andy Warhol, *Do It Yourself (By the Sea)*, 1962, acrylic and transfer numbers on canvas, 138 x 182.9 cm, Marx Collection, Berlin, on permanent loan to Städtisches Museum Abteiberg, Mönchengladbach.

P. 104: Andy Warhol, *Torso*, 1977, silkscreen on acrylic on canvas, 127 x 107 cm, private collection.

P. 105: Andy Warhol, *Torso*, 1977, silkscreen on acrylic on canvas, 127 x 107 cm, private collection.

P. 106: Andy Warhol, *Camouflage*, 1986, silkscreen on acrylic on canvas, 295 x 1067 cm, Andy Warhol Foundation for the Visual Arts, Inc., New York.

P. 107: Andy Warhol, *Camouflage*, 1986, silkscreen on acrylic on canvas, 193 x 193 cm, Andy Warhol Foundation for the Visual Arts, Inc., New York.

P. 108: Andy Warhol, *Rorschach Inkblot Test*, 1984, acrylic on canvas, 417 x 292 cm, Andy Warhol Foundation for the Visual Arts, Inc., New York.

P. 109: Andy Warhol, *Rorschach Inkblot Test*, 1984, acrylic on canvas, 401 x 279 cm, Andy Warhol Foundation for the Visual Arts, Inc., New York.

Warhol Today

P. 111: Andy Warhol and Jean-Michel Basquiat, photograph.

P. 112: Contents of a *Time Capsule*, photograph.

P. 113 top: Andy Warhol's collection of cookie jars at the Andy Warhol Museum, Pittsburgh, photograph.

P. 113 bottom: Lou Reed and John Cale, *Songs for Drella*, cover.

P. 114: *Andy Warhol. The Late Work*, 2004, exhibition at museum kunst palast, Dusseldorf, Germany, photograph.

P. 115: View of the *Andy Warhol. Dollar Signs* exhibition at the Leo Castelli Gallery, New York, 1982, photograph.

P. 116: Cover of the catalog for The Andy Warhol Collection, Sotheby's New York, 1988.

P. 117: Andy Warhol's kitchen, photograph in the catalog for The Andy Warhol Collection, Sotheby's New York, 1988.

P. 118: Jean-Michel Basquiat and Andy Warhol, *Untitled*, 1984, acrylic on canvas, 194.3 x 292.1 cm, private collection.

P. 119: Jeff Koons, *Rabbit*, 1986, stainless steel, 104.1 x 48.3 x 30.5 cm, private collection.

P. 120: Vase from the Andy Warhol Collection by Rosenthal, 2002.

P. 121: Model Devon wearing the Warhol T-Shirt from Diane von Fürstenberg's fall collection, 2002.

P. 122: Some of the cast in Julian Schnabel's film *Basquiat* (left to right): Jeffrey Wright, David Bowie, Gary Oldman, Dennis Hopper.

P. 123: Mike Myers and Mark Bringleson (as Andy Warhol) in *Austin Powers: International Man of Mystery*, 1997, film still.

Cover:

Front cover: Andy Warhol, *Campbell's Tomato Soup Can*, 1968 (page 38)

Back cover: Andy Warhol and some Factory associates (page 19)

Outside front flap: Andy Warhol, detail of the album cover for *The Velvet Underground* (page 7)

Inside front flap: top, l. to r.: "Black Friday" on the New York Stock Exchange, 1929; Elvis Presley; Humphrey Bogart and Ingrid Bergman in *Casablanca*; Jean-Paul Sartre; Martin Luther King; Pablo Picasso;
bottom, l. to r.: Andrew Warhola with his mother Julia and his brother, John (page 62, left); Andy Warhol (page 63); Andy Warhol, *Nancy* (page 69); album cover for *The Velvet Underground & Nico* (page 7, bottom); cover of the first edition of *Interview* (page 78); cover of *The Philosophy of Andy Warhol* (page 74, left); Andy Warhol, *Oxidation Painting* (page 52).

Page 1: Andy Warhol, *Brillo, Del Monte and Heinz Tomato Ketchup Boxes*, 1964 (page 35).

Inside back flap: l. to r.: "Baby" Jane Hozer (page 45); Fred Hughes (page 76); Gerard Malanga (page 19); Brigid Polk (page 21); Viva (page 91).

If you want to know more

Andy Warhol in his own words:
After Andy Warhol's death, his friend Pat Hackett edited *The Andy Warhol Diaries*, based on recordings of telephone conversations she had with the artist between November 1976 and February 1987. New York and London, Simon & Schuster, 1989.

In *POPism: The Warhol Sixties*, Andy Warhol and Pat Hackett consider the Pop phenomenon in 1960s New York. Orlando, Florida / Harcourt, 2006 (first published in New York, 1980).

Warhol's views on life and art can also be found in *The Philosophy of Andy Warhol (From A to B and Back Again)*, New York / Harcourt Brace Jovanovich, 1975.

His many interviews are represented in *I'll Be Your Mirror: the Selected Andy Warhol Interviews: 1962–1987*, edited by Kenneth Goldsmith, introduction by Reva Wolf, afterword by Wayne Koestenbaum, New York / Carroll & Graf, 2004.

About Andy Warhol
Exhaustive coverage of Warhol's output is provided by *The Andy Warhol Catalogue Raisonné*, edited by Georg Frei and Neil Printz, New York and London / Phaidon Press, 2004.

In 2004, the museum kunst palast in Düsseldorf, Germany, devoted an exhibition to the last fifteen years of Warhol's creative life. The lavishly illustrated three-volume exhibition catalogue appeared as *Andy Warhol. The Late Work*, Munich / Prestel, 2004.

Andy Warhol "Giant" Size 15cc Plus 1 Tower, with contributions by Dave Hickey, Kenneth Goldsmith and others, is a "big" read. New York and London / Phaidon, 2006.

Several members of the Factory "crew" have published reminiscences of their time with Warhol, including: Gerard Malanga, *Archiving Warhol, An Illustrated History*, London / Creation Books, 2002; and Debra Miller and Billy Name, *Stills from the Warhol Films*, Munich / Prestel, 1994.

For those interested in Warhol's portraits, a central aspect of his art, there's *Andy Warhol. Portraits*, which was published to accompany the exhibition *Andy Warhol's Portraits of the Seventies and Eighties*. Munich / Prestel, 1993.

For lovers of shoes and fashion there's *Andy Warhol Fashion*, with a foreword by Simon Doonan, London / Thames & Hudson, 2004.

Warhol's depictions of men in various media (illustrations, paintings, drawings, silkscreen prints, Polaroid studies and fine art photographs) are the subject of *Andy Warhol Men*, foreword by Alan Cumming, London / Thames & Hudson, 2004.

Warhol as collector was the focus of an exhibition at the Andy Warhol Museum in Pittsburgh, and at the Museum für Moderne Kunst in Frankfurt am Main. The catalogue was published as *Andy Warhol's Time Capsules*, Cologne / DuMont Literatur und Kunst Verlag, 2003.

A study that sets Warhol in the broad cultural context of New York in the 1960s is Reva Wolf's *Andy Warhol, Poetry and Gossip in the 1960s*, Chicago / University of Chicago Press, 1997.

For those interested in the philosophical aspects of Warhol's work there's Arthur C. Danto's *Beyond the Brillo Box: the Visual Arts in Post-historical Perspective*, New York / Farrar Straus Giroux, 1992.

Finally, two books for younger readers: Linda Bolton, *Andy Warhol*, London / Franklin Watts, 2002; and Susan Goldman Rubin, *Andy Warhol: Pop Art Painter*, New York / Abrams Books for Young Readers, 2006.

Imprint

The pictures in this book were graciously made available by the museums and collections mentioned, or have been taken from the Publisher's archive with exception of:
RAPHO/laif: Page 8
Finkelstein/laif: Page 60
James Klosty, with thanks to the Cunningham Dance Foundation: Page 12
ullstein bild: Pages 19, 44
ullstein-dpa: Page 20
ullstein-KPA: Pages 58, 123
ullstein-Constantin Film: Page 91
ullstein – photoreporters inc.: Page 45
© The Andy Warhol Museum, Pittsburgh: Pages 21 above, 50, 51, 65, 93
Harry Shunk: Page 26 right
Courtesy Leo Castelli Gallery, New York: Page 43
Associated Press: Pages 57, 76, 111 (Richard Drew), 112 (Michael Probst), 113 above (Gene J. Puskar), 114 (Fabian Bimmer), 121 (Stuart Ramson)
akg-images: Page 77
Jeff Koons studio: Page 119
Rosenthal AG, Selb: Page 120
© Corbis Sygma: Page 122
© Ugo Mulas Estate. All rights reserved: Page 11

The Library of Congress Control Number: 2007929004
British Library Cataloguing-in-Publication Data: a catalogue record for this book is available from the British Library. The Deutsche Bibliothek holds a record of this publication in the Deutsche Nationalbibliografie; detailed bibliographical data can be found under: http://dnb.ddb.de

© Prestel Verlag, Munich · Berlin · London · New York 2007
reprinted 2008

Prestel Verlag
Königinstrasse 9
80539 Munich
Tel. +49 (89) 38 17 09-0
Fax +49 (89) 38 17 09-35

Prestel Publishing Ltd.
4 Bloomsbury Place
London WC1A 2QA
Tel. +44 (0) 20 7323-5004
Fax +44 (0) 20 7636-8004

Prestel Publishing
900 Broadway. Suite 603
New York, N.Y. 10003
Tel. +1 (212) 995-2720
Fax +1 (212) 995-2733

www.prestel.com

Translated from the German by Stephen Telfer, Edinburgh
Editorial direction by Claudia Stäuble
Copy-edited by Chris Murray, Crewe
Series editorial and design concept by Sybille Engels, engels zahm + partner
Cover, layout, and production by Wolfram Söll
Lithography by Repro Ludwig, Zell am See
Printed and bound by Druckerei Stürtz GmbH, Würzburg

Printed in Germany on acid-free paper

ISBN 978-3-7913-3814-9